# The Ground on Which I Stand

Number Twenty-Two

**SAM RAYBURN SERIES ON RURAL LIFE**

Sponsored by Texas A&M University–Commerce
M. Hunter Hayes, General Editor

*A list of books in this series is available at the end of the book.*

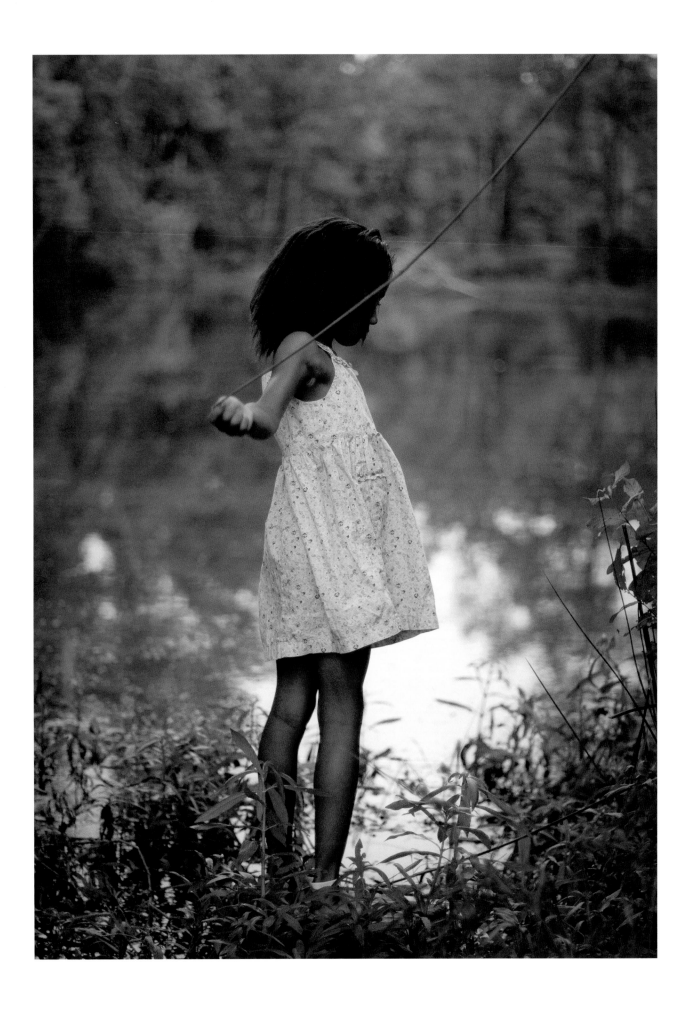

# The Ground on Which I Stand

*Tamina, a Freedmen's Town*

## MARTI CORN

Foreword by *Tracy Xavia Karner*

Introduction by *Thad Sitton*

Contributions by *Wanda Horton-Woodworth*

and *Tacey A. Rosolowski*

TEXAS A&M UNIVERSITY PRESS
*College Station*

This paper meets the requirements of ANSI/NISO z39.48–1992 (Permanence of Paper).
Binding materials have been chosen for durability.
Manufactured in United States of America

Library of Congress Cataloging-in-Publication Data

Names: Corn, Marti, author. | Karner, Tracy X., 1959– writer of foreword.
Title: The ground on which I stand : Tamina, a freedmen's town / Marti Corn ;
foreword by Tracy Xavia Karner.
Other titles: Tamina, a freedmen's town | Sam Rayburn series on rural life ;
no. 22.
Description: First edition. | College Station : Texas A&M University Press,
[2016] | Series: Sam Rayburn series on rural life ; Number Twenty-two |
Includes bibliographical references and index.
Identifiers: LCCN 2015044708| ISBN 9781623493769 (cloth : alk. paper) |
ISBN 9781623493776 (ebook)
Subjects: LCSH: African-Americans—Texas—Tamina—History. |
African-Americans—Texas—Tamina—Pictorial works. |
African-Americans—Texas—Tamina—Interviews. | African-American
families—Texas—Tamina—History. | African-American
families—Texas—Tamina—Pictorial works. | Tamina (Tex.)—History. |
Tamina (Tex.)—Pictorial works. | LCGFT: Oral histories.
Classification: LCC F395.N4 C67 2016 | DDC 976.4/153—dc23 LC record available at
http://lccn.loc.gov/2015044708

The color images in this book were created during the period from 2010 to 2014.
All images, unless otherwise noted, are by the author.

Frontispiece: Jada Chevalier beside the pond near the family home.
See chapter 2, The Chevalier Family, beginning on page 17.

*To all those who call Tamina home*

# We Shall Gather

Near the tracks
where our daddies loaded timber.

Near the spring water pond
of our baptismal faith.

Near the sweet grass and pitch pine fields
our horses graze.

Near our open-handed neighbors
waving from the porch.

Near our hymns
swelling up on Sundays.

Near our children
and our children's children.

Under oaks we planted years past
in Tamina's free air.

*—Hallie Moore*

# CONTENTS

# SERIES EDITOR'S FOREWORD

*M. Hunter Hayes*
General Editor, Sam Rayburn Series on Rural Life

It is a tremendous pleasure to welcome Marti Corn and her *The Ground on Which I Stand* to the collection of books that constitute the Sam Rayburn Series on Rural Life. Through each of its twenty-one previous volumes, the Rayburn Series has presented works that examine the history and culture of individuals and diverse population groups that bear witness to aspects of life across rural areas in the eastern half of Texas. Although many of these subjects have held a delicate purchase on the awareness of residents within and beyond Texas, their histories and impact on life today continue to resonate and unite in unexpected ways. In the Rayburn Series, a focus on a sense of community serves as a thread that stitches together the unique fabrics of these distinct books. Perhaps no other book in the series represents the concept of community as absolutely as Marti Corn's *The Ground on Which I Stand*.

Combining a series of stunningly beautiful photographs of Tamina and its residents, accompanied by the stories of these individuals in their own words, Corn's book conveys to the reader a permeating sense of pride in this community. Situated south of Conroe and just east of I-45, Tamina originated in 1871 as Tammany, a town for freed slaves. Notably, the town holds an important link to its origins through its inhabitants, many of whom descend from Tamina's founders. As Corn writes in the afterword, she found Tamina to be "a historically significant town with important stories to be told," and her documentary method of combining a photographic essay with the oral histories of selected residents allows the telling of the stories through multiple perspectives that unite to provide the reader with a rich understanding of a community that will likely be unfamiliar to those residing outside the region. Drs. Tracy Xavia Karner, Thad Sitton, and Tacey A. Rosolowski provide, in their eloquent and richly perceptive commentaries, important contexts that amplify the significance of Tamina specifically and the few remaining similar communities.

As a result of Corn's astute perception that the Tamina community deserves celebration and her dedication to her project and to the residents of Tamina,

readers may now share in this celebration. A key component of this celebration, it seems to me, is to begin understanding the many complexities of Tamina, which occupies a rural area surrounded by larger, more economically-privileged communities. Corn and her collaborators in this book share a sense of community in conveying these complexities to the reader and allow outsiders temporary residence upon the firm ground of this community.

When James A. "Bo" Grimshaw Jr. founded the Rayburn Series, initiated in 1997 under the auspices of the Texas A&M University Press with its first volume published in 2000, part of his vision for the series was that the individual volumes would comprise a finely-woven tapestry of life experiences in East Texas. As the series has expanded, depicting the joys, tragedies, and daily business of life in the region, images of various communities both large and small have provided the lacework for the mosaic-like tapestry that Bo Grimshaw envisioned. Marti Corn's inspiring tribute to the residents of Tamina and their shared history is a welcome addition to the Sam Rayburn Series on Rural Life, and it is an honor to include *The Ground on Which I Stand* in the series.

# FOREWORD: STORIED LIVES

*Tracy Xavia Karner*

Ethnographer Ruth Behar calls herself a storyteller who has been seduced by the allure of fieldwork—by the beauty and the mysteries of the lives of others. Whether with audio recorder or camera, her desire is to "find the stories we didn't know we were looking for in the first place."[1] In *The Ground on Which I Stand*, Marti Corn has done just that. She found a story—or perhaps it might be more accurate to say the story found her—as she became aware of a neighboring community, Tamina, that had been isolated and rendered socially invisible for much of its existence. Curious about its history and cultural significance, Marti began her fieldwork like an ethnographer—getting to know the residents and participating in the community long before bringing her camera.

Freedmen's settlements are a little known part of post-civil war history in Texas. History, the saying goes, is written by those in power. So, it is not surprising that we hear certain kinds of voices rather than others. The further back we go in the past, the smaller the proportion of people who could read, write, and record their history of those times. Additionally, only certain kinds of documents are preserved through time; others have either been thrown away, lost, burned accidentally or purposely, or in other ways rendered unavailable. Historians Thad Sitton and James Conrad speculate that illiteracy, as well as other disadvantages faced by blacks in Texas, are part of the reason we know so little about these communities. In their research, they spoke with a woman who had interviewed the elderly women of her freedmen town about their lives under slavery. She had recorded their stories on brown wrapping paper she kept under her bed.[2] In communities such as Tamina, stories and oral histories take on a central importance and become a bridge to the past when written documents are scarce or nonexistent.

The use of images, both still and moving, has long been used to document and understand communities. From the pencil sketches and watercolor drawings of pre-modern travelers to the photography used by early anthropologists, images have played an important role in conveying culture and experience. Anthropologist Robert Flaherty filmed Eskimos in the 1920s, while Margaret

Mead and Gregory Bateson filmed everyday life in Bali in the 1930s. Indeed, almost from its invention, photography has been used to document social life at home and abroad. The world that is seen through photographs or other images, visual sociologist Douglas Harper contends, is different than a world comprehended through words or numbers.[3]

Though Marti considers herself a documentary photographer, she has completed a more comprehensive portrait of a community. Beyond the compelling visual images, she includes interviews and historical pictures to offer the viewer an expanded look at this relatively unknown town. By collecting stories and taking photographs, Marti offers traces of both the residents of Tamina and the community. In her photographs, we meet "The Faces of Tamina" and with the interviews, we hear the residents' voices. The photographs and stories document the qualities of social relationships, the fragility of community, and the sense of belonging to a place in ways outsiders may have never known. With her focus on storied lives and lived experiences, her work helps viewers transcend categories and stereotypes.

One of the most profound aspects of photography is its ability to evoke what neuroscientists call narrative empathy. Studies have found that any activity that encourages us to explore someone else's perspective increases an empathic response. As human beings, we are hard-wired to respond to stories, because they ask us to imagine what it would be like to be someone else. Reading the stories of Tamina, we hear the individuals' voices in our heads.

When we look at a portrait, our mirror neurons fire, calling forth a similar response in our brains to the pictured individual. Looking into the eyes of a person in a photograph can also bring about an oxytocin release, helping us to feel connected to the individual in the portrait. Marti's direct and collaborative approach to image creation results in photographs that are as immediate and striking as they are accessible and engaging.

The stories we tell, whether in photographs or words, are embedded in a specific time, place, history, and culture—all of which help shape and form the narrative. As such, *The Ground on Which I Stand* is both the collective story of a community and individual stories of the residents. It is the story of a past and present with a glimpse of an uncertain future. By sharing their stories, the residents of Tamina are sharing the essence of their lives—what has happened to them, the important events, experiences, and feelings of a lifetime. By doing so, they are also telling the story of their community, of their collective history, of their shared values and concerns. Their stories are like gifts, generously offered and respectfully documented by Marti. Tamina has opened her arms, and viewers are invited to imagine and understand their ways of being in the world.

Throughout history, stories have been used to teach, to entertain, to express, to advocate, and to organize meaning. It is through the sharing of stories that communities build their identities, pass on traditions, and construct meaning. We hear the sustaining narratives of church, family, and community in the stories of Tamina. In the photographs, we meet Reginald Chevalier proudly standing in front of the house he built himself, and we witness Johnny Jones in jubilant song; Ranson and Shirley Grimes relax on their porch, while choir director Ruth Watson gazes self assuredly at Marti's lens.

We see the trappings of rural poverty, remnants of racial discrimination, and the prevalence of horses in this still mostly pastoral community. In both the stories and the images, the importance of community is clear. Residents have relied on each other over the years and cared for each other through the generations. People talk of community as nearly synonymous with family. *The Ground on Which I Stand* shows a community that embodies the importance of social bonds and what it means to belong to a place.

Images, as well as stories, can provide a way to remember and retell experiences. *The Ground on Which I Stand* contributes to the historical record of freedmen's settlements in Texas, expanding our understanding of ourselves and our neighbors. This work stands as a testament to the significance of social connections in overcoming barriers and challenges—and to the strength and perseverance of individuals. Respectfully and faithfully documented, this work illustrates the integrity inherent in the collaborative processes of both photographers and ethnographers alike. Working with the residents of Tamina, Marti has helped them share and tell their stories to create a compelling portrait of a community that represents an important chapter in our history that should not be forgotten.

NOTES

1. Behar, Ruth. "Ethnography and the Book that was Lost," *Ethnography* 4(1): 15–39.
2. Sitton, Thad, and James H. Conrad with Richard Orton. *Freedom Colonies: Independent Black Texans in the Time of Jim Crow*. Austin: University of Texas Press, 2005.
3. Harper, Douglas. *Visual Sociology*. New York: Routledge, 2012.

# PREFACE

When slaves were at last given their freedom, the vast majority became share-croppers, tenant farmers, and day laborers. Fewer than 2 percent of the freedmen had the money to purchase land. The families who established Tammany in 1871 were among this minority. While a few families came from surrounding Texan counties, most traveled from Virginia, Maryland, Arkansas, the Carolinas, Alabama, and Louisiana, eventually making their way to Tammany through the Port of Galveston, once the largest slave port and tagged as the entry "from the Congo to Conroe." After Juneteenth though, the port became an entry-way for those finding a new life where there was the promise of inexpensive fertile land and work in the sawmills.

Located north of Houston and ten miles south of Conroe, Tammany was far from other towns. The land was owned by a military captain who had made his way there years earlier from New York and was willing to sell his land to freed-men. Before his arrival, the area had been known as Little Egypt, and preceding that, the Badai Indians lived here.

It was an ideal location. Property could indeed be purchased inexpensively, and there was work to be found in Montgomery County's growing logging industry.

The railroad had just been completed running from Houston to Conroe, giving residents the opportunity to flag the trains down to take them to Houston when needed. Mail could be dropped and collected here, and household necessities and food items they were not able to grow could be brought in. The train also served as a means to transport the cord and pulp wood to Houston.

Here, they built their homes, churches, a one-room schoolhouse, and a general store. They raised hogs and tilled their own land. Gradually, the town's name changed to Tamina, though many residents continue to use the original pronunciation.

From the late 1800s throughout the 1960s and '70s, Tamina was home to several cafés and even a house of prostitution and was well known throughout the region for its home-brewed "white lightning" whiskey—all of which supported the

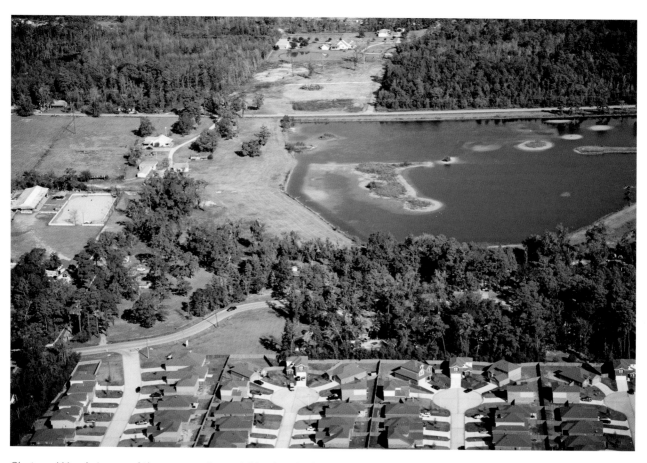

Chateau Woods is one of the surrounding neighborhoods that hedges what remains of Tamina.

local sawmill workers. But when The Woodlands, Shenandoah, Chateau Woods, and Oak Ridge encroached on Tamina, all these businesses closed down.

Dramatic changes occurred due to the growth surrounding Tamina. Today, the residents see this as an opportunity to have the best of both worlds. While Tamina remains a rural town with small-town values, they are surrounded with opportunities only larger cities can offer. Their children now attend some of the best schools in the country, employment opportunities surround them, entertainment and cultural events are a stone's throw away, and the faith-based community and services in the surrounding communities, such as Interfaith, United Way, the YMCA, The Friendship Center, and Montgomery County Food Bank, are there to offer assistance.

Half of the working-age residents are employed in the surrounding cities and in Houston; the others struggle for survival due to lack of job skills, continued education, and transportation.

Tamina is one of the few remaining freedmen's towns in the United States.

———◆———

Fifteen people and their families from Tamina opened their homes and voices to me so I could document their personal stories, memories, and family history.

The residents I interviewed and photographed represent different aspects of this community—young and old, black cowboys, ministers, those who have created nonprofits to help their neighbors, a man struggling to find his way after thirty years in prison, another who continues the town's legacy working in the tree industry, those whose families have lived in Tamina for six generations, and folks who moved to Tamina within their lifetime.

Their stories tell of a deep-rooted kinship with one another, with their values resting on family and community. No matter what happens, these neighbors are there to care for one another. When someone is ill, the community comes together to help in any way they can. Over and over again, people recount opening their doors to anyone who knocks and might be hungry. Without question, an extra place is set, and they all share a meal around the kitchen table. They have lived through the years of Jim Crow Laws, the Depression, war, and the civil rights movement. Regardless of the challenges faced, their faith, gratitude, and humor always thread their tales.

———◆———

When I drive through this town, I see a group of people filled with grace, those who have struggled with poverty and prejudice. I see a community that has been gifted with the opportunity to send their children to some of the best schools in

the country, thanks to the growth of surrounding cities. And I see a community that is at risk of gentrification as real estate values escalate and surrounding cities eye Tamina land for development. There are few people that recognize their triumphs and struggles, and thus I have become dedicated to bringing their stories to light.

Perhaps the risk of losing this unique Texas heritage compelled me to document, in portraiture, the lives of these individuals, their families, and their community, along with their stories told in their own voices. I am deeply indebted to and enriched by each of them for allowing me to share these stories with you.

My hope is that I have created a body of work that honors both the history of one of the few remaining emancipation communities in the country and the grace in which the members live their lives. Perhaps those who study the portraits and read their stories will gain a deep appreciation and respect for all Tamina has endured and will realize the importance of preserving this historic community.

This is *The Ground on Which I Stand*.

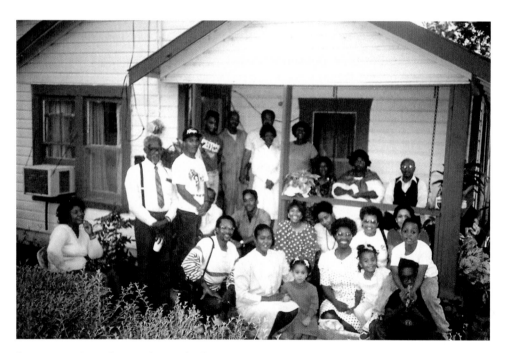

Four generations: Descendants of Julia Randle (Aunt Julia) and Willie Lee Randle gather at the home of Rheade and Ruth Amerson (Aunt Julia's daughter). Circa 1990. This is the same house as shown on page 2. *Photo courtesy of Wilmeter Amerson-Haynes*

# INTRODUCTION: FREEDMEN'S SETTLEMENTS

*Thad Sitton*

Freedmen's settlements were independent rural communities of African American landowners and land squatters that formed in the eastern half of Texas in the years after Emancipation. These "freedom colonies," as blacks sometimes called them, were to a degree anomalies in a post-war Texas where white-power elites rapidly resumed social, economic, and political control and the agricultural system of sharecropping came to dominate.

Freedmen's strong desires for land, autonomy, and isolation from whites motivated formation of these independent black communities. After the 1865 rumor that the federal government soon would provide all ex-slaves with "forty acres and a mule" proved baseless, most freed persons remained in the countryside and took employments with white landowners as day laborers, sharecroppers, or share tenants. Another large group of ex-slaves moved to settle in segregated "quarters" adjacent to white towns. A minority of former slaves, however, set out to achieve the dream of forty acres and a mule quite on their own, and a remarkable number of them succeeded.

Landownership rates among African American farmers in Texas rose rapidly from 1.8 percent in 1870 to 26 percent in 1890 to the all-time high of 31 percent soon after 1900. Many of these new black Texas landowners resided in freedmen's settlements, informal communities of black farmers and stockmen scattered across the eastern half of the state. These were dispersed communities—"settlements," Southerners often called them—places unplatted and unincorporated, individually unified only by church and school and residents' collective belief that a community existed. Up in the sand hills, down in the creek and river bottoms, and along county lines, several hundred Texas freedmen's settlements came into being between 1870 and 1890. Many established themselves on pockets of wilderness, cheap land, or neglected land previously little utilized for cotton agriculture.

Some patterns of community origin are discernible, although their relative importance remains uncertain. As in the case of Barrett, in Harris County, many settlements existed for years as squatter communities before residents formally

purchased or preempted land. Ministers and their congregations took the lead in founding some communities, as at St. John Colony in Caldwell County. At County Line (now Upshaw), Nacogdoches County, and other places, groups of siblings formed the core pioneers of settlements. As at Shankleville, a single black family with unusual resources for land purchase might have served as patron for a black community, which then grew up around it. Motivated by paternal attitudes toward former slaves, friendships or blood relationships with former slaves, or simply the need for ready cash, whites occasionally assisted the origins of such settlements as Halls Bluff and Fodice in Houston County, Tammany (now known as Tamina) in Montgomery County, Grant's Colony in Walker County, and Kendleton in Fort Bend County.

Freedmen's settlement families clung tenaciously to their lands, although these fragmented into smaller and smaller holdings across the generations. By the 1920s, many residents found it necessary to rent additional agricultural lands nearby, rent-farm for whites, or work in town. The sequential impacts of the Great Depression and World War II led to the depopulation of many Texas freedmen's settlements, though some survived into the twenty-first century.

Tamina is one of those surviving freedmen's settlements.

# The Ground on Which I Stand

# The Landscape

Tucked between The Woodlands, Shenandoah, Oak Ridge and Chateau Woodlands lies Tamina. It is just east of Interstate 45, about thirty miles north of Houston and ten miles south of the city of Conroe.

Today, Tamina is a small, unincorporated town in southern Montgomery County, Texas, encompassing about 450 acres of land with the Missouri Pacific Railroad running along its west end.

When established in 1871 though, as told by the town's elders, Tamina covered a far greater area, reaching north to Minnox (a town that was located just south of Conroe), west to Magnolia, east to the San Jacinto River, and south to Halton (a town that was just north of Rayford).

This emancipation town's landscape has a unique pastoral charm. Several churches line the main street running parallel to the railroad tracks. Eighty-year-old live oaks shade houses built years ago. Horses can be found along most streets behind wooden fences or tethered to a tree.

While some roads are paved, most remain dirt roads covered with gravel. There are no sidewalks. There are a few homes that have recently been built, but most are simple wooden structures built in the mid-1900s, many of them in disrepair.

There are a handful of businesses based in town including a tree service and a cement company, but this quiet town presents a striking contrast to the thriving communities and cities which hedge its borders— The Woodlands, Oak Ridge, Chateau Woods, and Shenandoah—all of which were built on what was once Tamina.

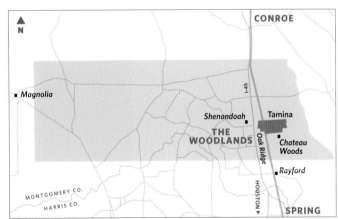

In 1871, Tamina encompassed a far larger area, shown in light green, than today's few-square miles of territory, shown here in dark green.

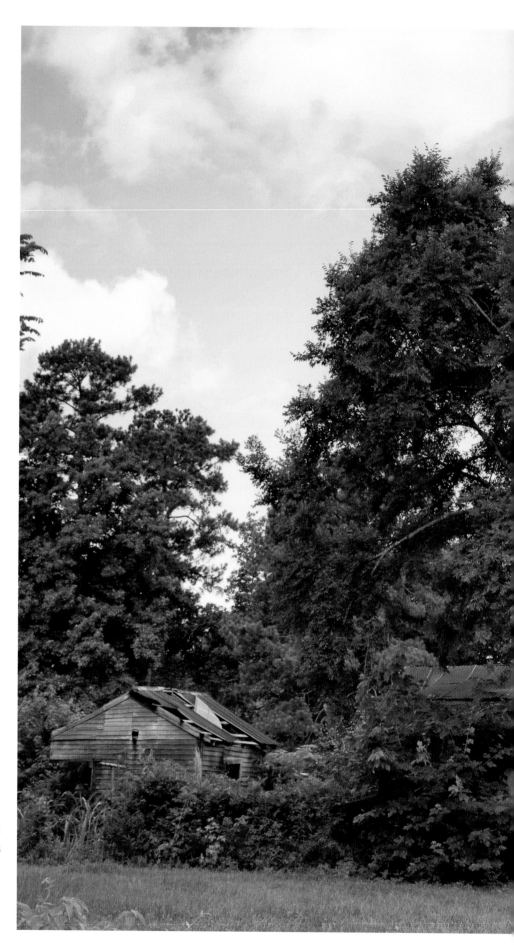

Even though there is a pastoral charm to this community, most homes, churches, and buildings are in disrepair.

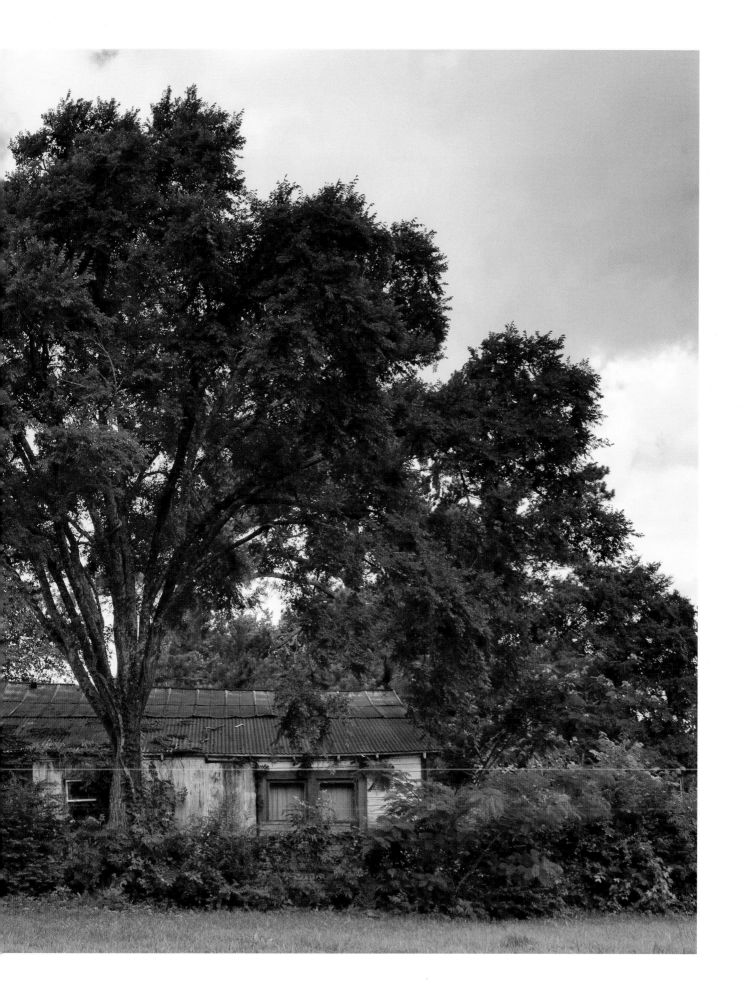

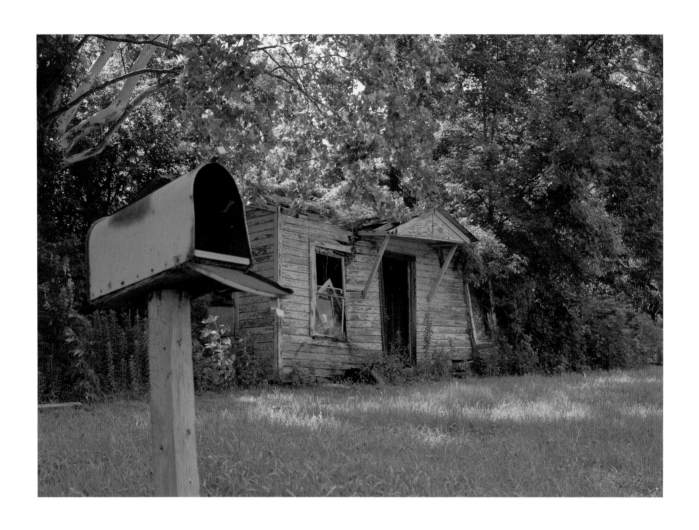

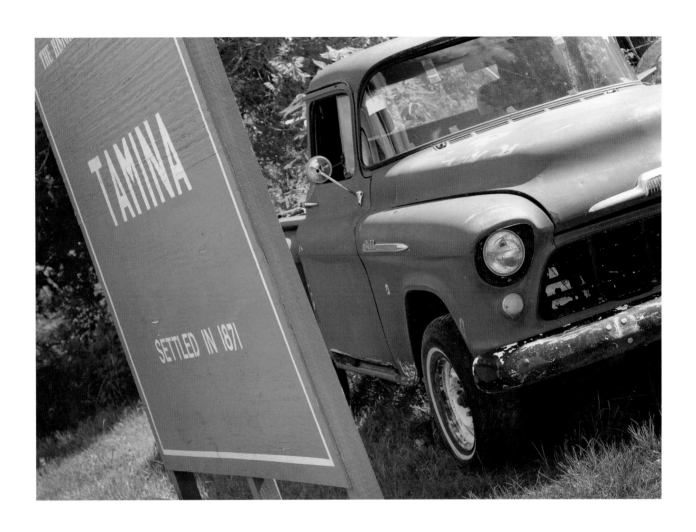

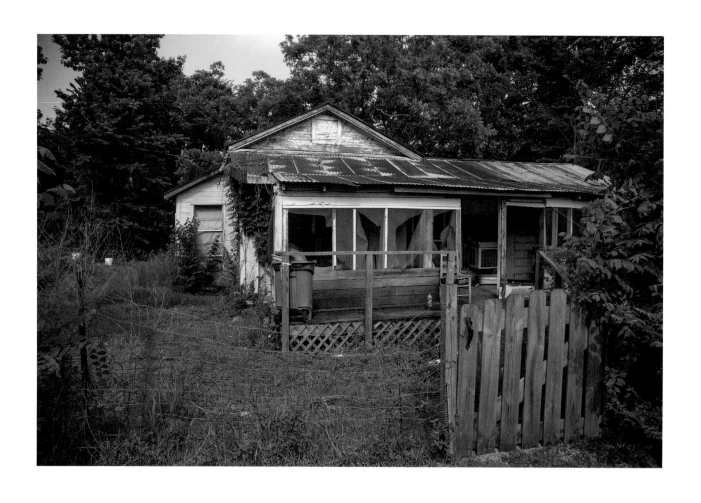

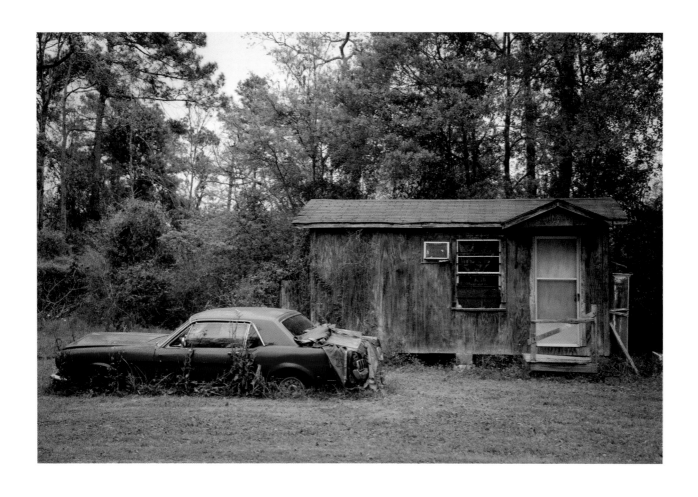

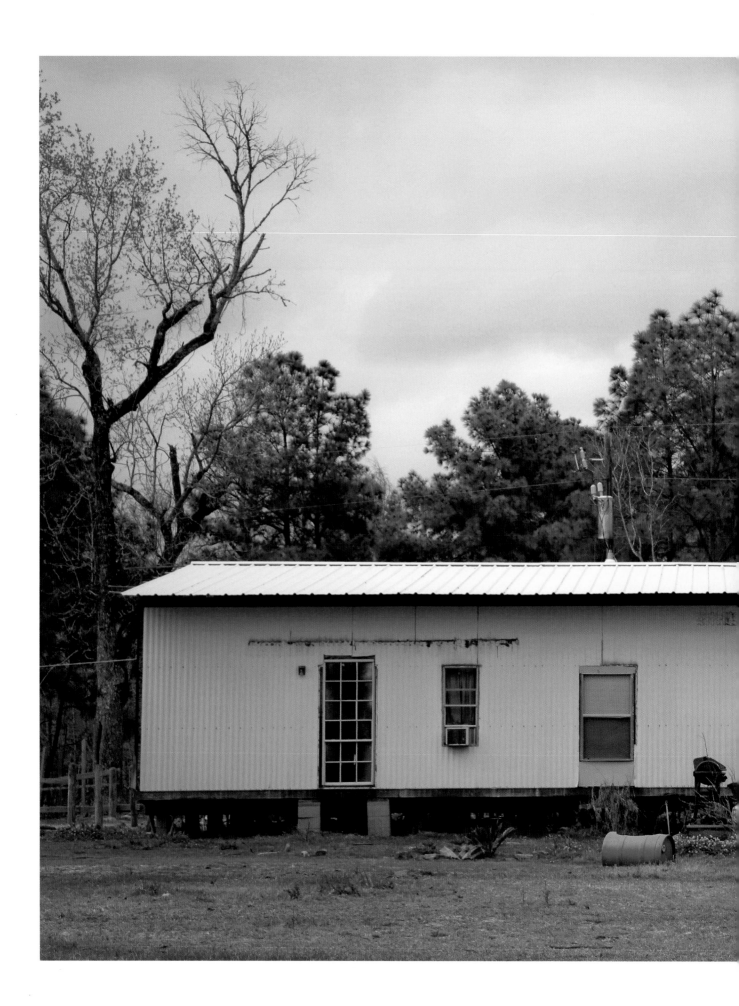

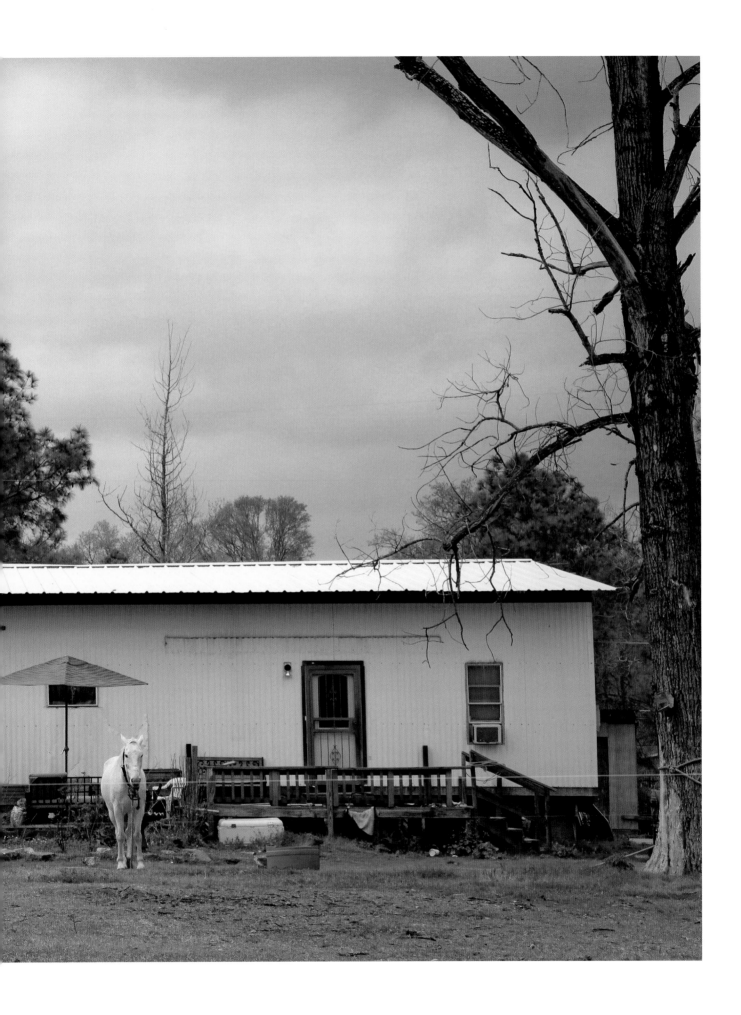

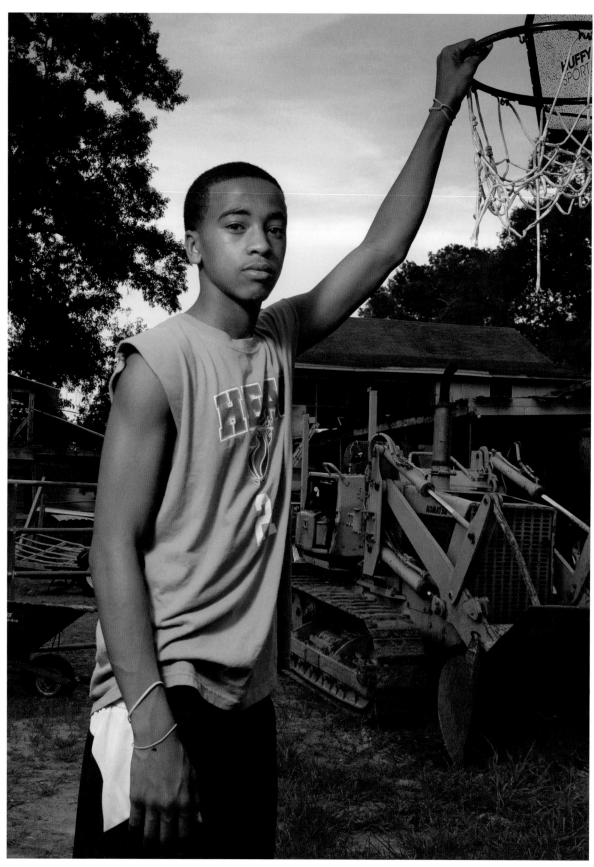

Jaren Chevalier outside his home.

# The Chevalier Family

"It doesn't matter if you're related or not, you're still thought of as family."

My name is Jaren Chevalier. I'm seventeen, and I attend Oak Ridge High School.

People are close here in Tamina. My friend, Patrick, and I grew up with each other, and for years we didn't even know we weren't brothers. That's what you do here, you call your friends, "brother."

When I was younger, people would come from all over the place just to be together, even people you'd swear you've never met before in your life. It doesn't matter if you're related or not, you're still thought of as family, and you're invited to join in. That kind of relationship is really important for the kids in Tamina.

When I was growing up, basketball became real important to me. I used to go to the Tamina Community Park to shoot baskets. First, it was because I was kind of lonely for my dad, 'cause he wasn't always around. He was busy working and trying to make money for the family. Then, I realized basketball was something I really wanted to do. I loved being on the court. I practiced and practiced, and now I'm a starter on the JV team. Basketball keeps me focused and gives me something to work for. It brought my family together, too. My family's never missed one of my games. My dad even helped coach my teams when I played in leagues before high school, and the rest of my family cheers me on in the stands.

I dream about going to college at Georgetown University or Syracuse University so I can play basketball there. I want to give my kids the things I didn't have, just like my dad has worked hard to give our family what we need. You know, he's even thinking about going overseas to Afghanistan to work as a mechanic and make good money to send home to us. It's hard to know what I will do after school. There's a part of me that wants to travel and maybe live in another state, but we are such a tight family, it would be hard to leave.

Tamina has given me a good start. In town, I see signs inviting businesses to build. I like seeing them. Oak Ridge High School is supposed to get bigger and bigger. Maybe new houses will be built, maybe apartments. I want this town to grow. I have watched our house grow the whole time I have been living here.

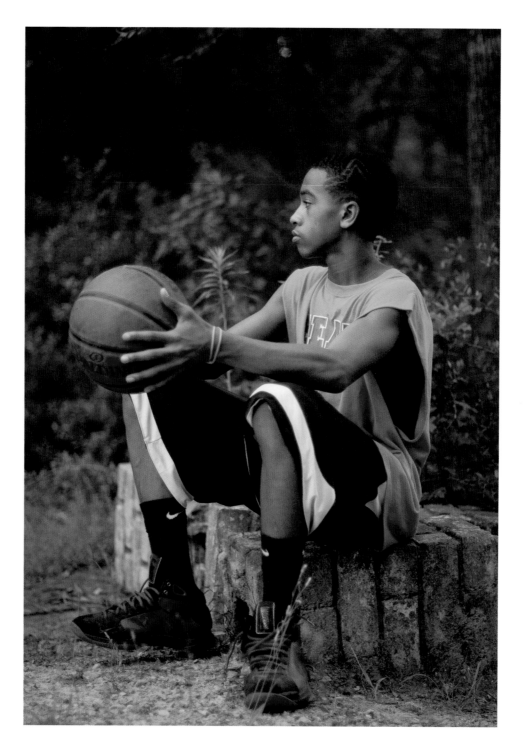

"When my dad was away working, I'd go to the community center and shoot baskets. It was then I realized basketball was something I really wanted to do."

—Jaren Chevalier

## "I'm bonded here, with Tamina."

I'm Jaren's dad, Reginald Chevalier, and I've been living in Tamina for 25 years or so.

Even though my dad didn't have property here until 1950, our descendants were some of the early settlers of Tamina. There are Chevaliers buried in Sweet Rest Cemetery who were born in the 1800s. I visit them every Juneteenth and help clean up the cemetery. I bought this acre of land for eighty-five dollars from my uncle Alfred Burgess's estate.

When we were kids, my mom and dad would drive us up here on weekends to play, and then, when I was nineteen in '85, we moved here permanently. I became a mechanic for the Houston Independent School District and spent more than twenty years helping repair all the schools' vehicles.

I'm a fixer and a builder. I built this house—actually, I've been building it for quite a while. The first house on this land burned down. Instead of rebuilding it, I moved to this side of the property and started a new one. All the wood is piecemeal. As my family's grown, I have built on more and more.

I have five children. Reginald is thirty-one and Regina, twenty-seven. Tiara is my stepdaughter, then there's Jaren, seventeen years old, and little Jada, only seven. I will finish this house one day, I guess. There are fewer than one hundred houses in Tamina, and some say mine is strange looking, but it's what I've created, and it's real important that I have kept this property. This is my history here.

I hope my children choose to stay close by. My oldest son would like his kids to be raised here. I'm the type that needs land. I need some space. I'm bonded here, with Tamina.

Reginald Chevalier

"It's real important that I have kept this property. This is my history here."

—Reginald Chevalier

Jaren has fond memories of watching and playing basketball with his dad. *Photo courtesy of Jaren Chevalier*

Barry Schuster, shown here with his mare, Angel, organizes a trail ride for family members and friends who drive from all over Texas and Louisiana to attend this tradition each Thanksgiving. Sometimes, more than one hundred riders attend.

# The Schuster Family

"It means a lot to see kids coming out [to a trail ride] wrapped up on a horse with their daddy."

My name is Barry Schuster, and I'm the president of the Tamina Trail Blazers.

My family lived in Houston until I was about 13 or 14. I was always the ornery one, and my mother didn't want to raise me and my six older brothers and baby sister in the big city.

A few years after my grandfather, Virgil Carter, moved to Tamina, my family followed in 1968. We got our own property, cleared it, and built a house. I spent a lot of time with my grandfather. He was a great storyteller and helped raise me.

To help me feel at home, my mother bought me my first horse. My, it was a real ugly horse, loaded with cockleburs. I shaved off every bit of his hair and mane to get rid of them. He was a sight! A miracle happened when it grew back though . . . I had a beautiful Welsh horse.

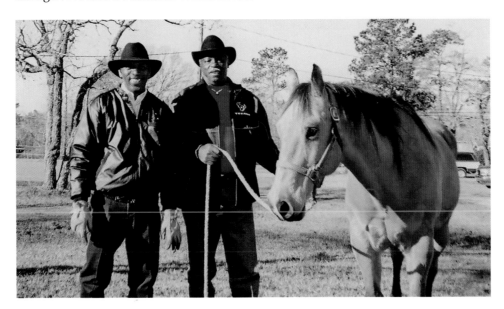

Barry Schuster and Ranson Grimes ready for their annual trail ride.
*Photo courtesy of Barry Schuster*

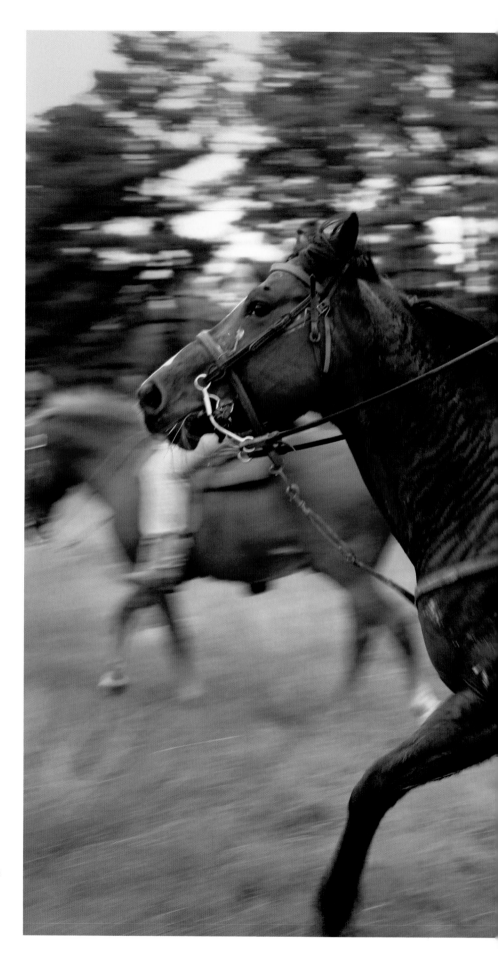

Barry Schuster helps guide this trail ride that took place along the outskirts of Old Town Spring.

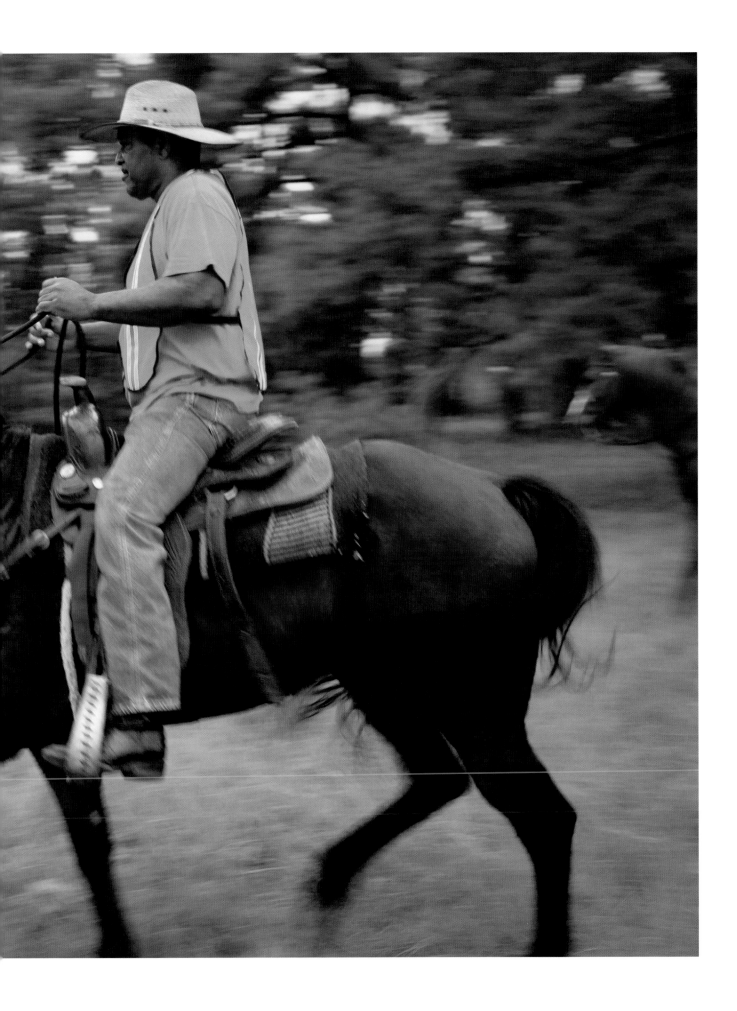

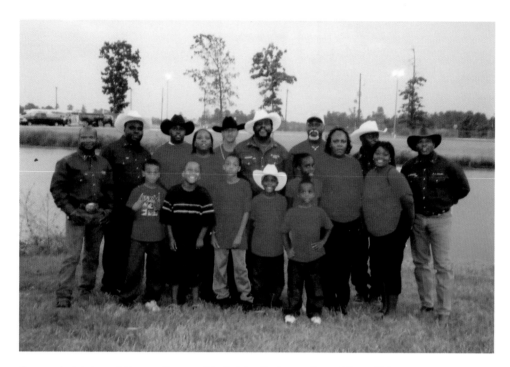

Group shot taken at the 2008 annual trail ride. *Photo courtesy of Barry Schuster*

I taught myself to ride by watching old Westerns and spending a lot of time in the saddle riding through the woods and the unpaved red-dirt roads. That was all there was in Tamina in those days. I hit the dirt a few times, too, on those rides, but I fell in love with horses, and I've been messing with them ever since.

In 2003, I started the Tamina Trail Blazers. My nephew, David Dorvil, has been riding with us since we started. It's just something to keep the community together. We have a yearly ride just before Thanksgiving. It starts with a big barbecue Friday night as all the families arrive. Then Saturday, breakfast starts at the crack of dawn. But, since we have the ride mostly for the kids, and they don't wake up until nine or ten, breakfast just keeps on going until people don't want any more food. Then, we get the horses groomed and ready and start the ride in the early afternoon. It means a lot to see kids coming out there wrapped up on a horse with their daddy. The two-year-olds and other little ones ride in a horse-drawn cart filled with hay.

It's family time with smiles, laughs, and a party after the ride. It's a beautiful way that Tamina can keep tight with the kids. David says he knows experiences like these have let him "be where I am today. I thank God for it. It made me a better man."

I hope all our Trail Blazer kids will say the same thing.

Cousins Cynthia McCullough and David Dorvil.

Della Mae Haywood-Henry, John Elmore's granddaughter, attended a one-room schoolhouse. She has lived her entire life in Tamina.

# The Elmore Family

John Elmore's travels and curiosity gave him a deep sense of connection with the world and a rich education.

John Archer Elmore, born August 3, 1887, settled in Tamina with his family near the end of the century.

His mother, Laura Elmore, left Alabama at age nine with her dad and sisters, finding their way to Texas through the Port of Galveston. Slavery was abolished when she was seventeen.

John's father, Wilson Eastland, was the son of U.S. Senator Dixon Louis. John and his sister had walked from Alabama to Texas when they found their freedom.

Wilson and Laura married and had eight children. Two became the first Negro school teachers in San Jacinto County. After moving around for many years trying to find work, they finally settled in Tamina, and the entire family worked farming, cutting lumber, and in sawmills.

John became the first Negro mailman in Montgomery County. "When I was eight, I carried mail from Tamina to Minnox for ten cents per day."

"The first land owned by my family was purchased by my oldest sister and brother. It consisted of fifteen acres at a cost of four dollars and fifty cents per acre. The family home was that of one large room with a dirt floor. Here, we ate and slept. Hunting, fishing, and gardening supplied our basic needs. Conroe was a booming sawmill town and was the source of major needs. It was always my task to pick up the necessities for the family.

"I was nearing thirteen years old in 1900 when I was heading back home from Conroe. Heavy, heavy rains were coming down, lightning was flashing, thunder roaring, and the trees were falling all around. Too young to know what was happening and too ignorant to know the danger that confronted me, I continued my journey home, and by God's grace I made it. The Storm of 1900 took its toll.

"My skin is very fair and my hair brownish and straight. I look very much like my half-white parents and relatives. I could get by with many things that

other blacks could not. These features really did help me acquire knowledge and information for my people.

"With no chance or opportunity to attend public school, because I had to help provide a living for the family when growing up, . . . there was a constant desire within me to learn more about this great big beautiful world and its people. The question, 'Where do I go?' was always on my mind."

John took to the road, searching for better jobs and discovering the country. "I heard famous black people during my travels: songstress Black Patty, comedian Billy Sam, Booker T. Washington, his nephew Roscoe Simmons, Marcus Garvey, and others. I was the first black person in Orange, Texas, to open a grocery store. It was called the New Improvement Grocery Company. I worked in a sawmill, as a longshoreman, and signed up for the Army. I traveled to San Francisco, Ohio, New York, and I dreamed of going to Africa."

In 1928, John returned to Tamina and opened a small grocery store. Even though all were suffering from the Great Depression, he was able to keep food on the table by working several jobs. "The store survived . . . and served the people of the community for many years after. Credit was extended to many of the old settlers in the community. Some of those included the Burgesses, Smiths, Taylors, Moores, and Nolands—all who bought tracks of land surrounding my neighborhood. We labored together and made the best of what was available to us."

Converted in his early years, faith was an important part of John's life, and he was certain God would guide him along the way. In 1957, when he was seventy years old, John finally found his way to Liberia, Africa. Lone Star Baptist Church and some of Conroe's businessmen sponsored his journey. "After an inspirational program was given in honor of those who were to travel, Rev. W. J. Jones drove me to the airport where I was met by friends and family cheering me on my way." He spent two months working with the people, visiting their churches, schools, and homes. "When I returned home, there was a letter from President Lyndon B. Johnson congratulating me for the services rendered by me abroad."

In the following years, John brought many African young men to Texas and helped them get their college educations. "I have lived to see a fifth generation grow up around me. I have family scattered throughout the states."

He may not have had the opportunity for the traditional schooling he so desired, but his travels and curiosity gave him a deep sense of connection with the world and a rich education.

—From *Where Do I Go from Here,* by Deacon John A. Elmore

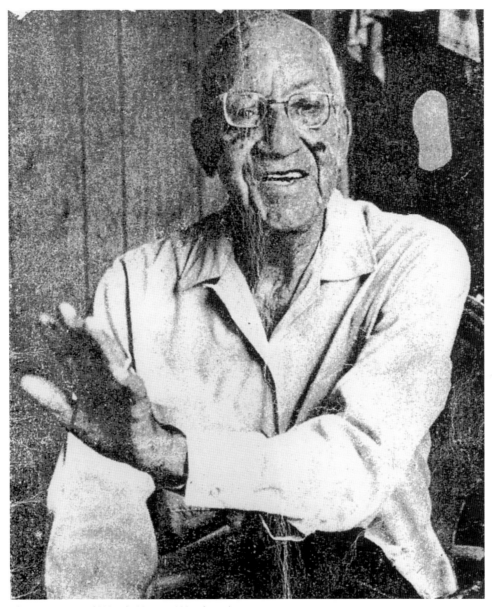

*Photo courtesy of Wanda Horton-Woodworth*

"There was a constant desire within me to learn more about this great big beautiful world and its people. The question, 'Where do I go?' was always on my mind."

—John Elmore

Cousin Harold Len Willis and
sisters Rita Haywood Wiltz and
Wanda Horton-Woodworth at
Sweet Rest Cemetery, where
their ancestors are buried.

*"I'm sixty four, and I've spent every summer of my life in Tamina."*

Rita and Wanda are my cousins, but Rita wasn't born until after I moved away from Tamina. Wanda, her older sister, though, was often left in my charge while we stayed at our great-grandmother's house.

I was born in Conroe in 1948 but lived in a little house in Tamina with my parents, my aunt, and great-grandmother until 1956 when I was twelve. That's when my parents and I moved to Houston so I could go to school in the city. But we always came back for the summer. Every summer! We would come back and help take care of the homestead.

The family sold the place years ago, but I remember it well. In all, we had two or three acres of prairie land. The house stood at the front of the property. There was a big wood stove in the middle of the dining room and another in the kitchen area. Behind the house was our plum orchard and the part of the property where we'd grow vegetables in the summer. A big Chinaberry tree stood back there too. Wanda fell out of it one day, and I got a whooping for letting her climb it. Seems she was always getting me in trouble. Out back, there was also a big barn where we kept a horse, cow, bull, and old-time farm equipment. We had chickens too and would borrow two mules to pull our plow when it was time to plant the garden.

Early in the morning, we younger kids would go outside and do chores. I couldn't really chop much wood because I was so young, but I did what I could and would stack all the wood each morning. My great-grandmother would make a fire under one of those great big old black kettles to make soap, and we helped by keeping the fire burning. The rest of the day we spent picking plums and canning vegetables. If there was something we didn't grow, there was always someone down the road we could trade with. As a treat, we sometimes made ice cream from scratch or ate ice-cold watermelon.

Being sure we had water was our other chore. Before we got the well dug on our property, we caught rainwater. The water would flow down the tin roof into three buckets. We kids were responsible for making sure the buckets were where they were supposed to be and emptied them into a barrel when full. When the rain barrels ran low, we would go to the artesian well, which is an underground spring under the lake in town. A line brought the water all the way to the road, and the spring had so much underground pressure, the line usually didn't even need to be primed. We'd take great big barrels to the hose by the side of the road, turn a lever, and fill up the barrels with that cold, fresh water.

When my great-grandmother turned 86, she went blind. It was tough after that, but whatever we needed to do, we would help out.

Harold Willis, a member of one of the oldest families in the community.

Rita Wiltz, a
community activist,
founded Children's
Books on Wheels
for her community
and those in need in
surrounding areas.

"My ancestors were the educators of the children, the readers, and the midwives."

I'm Rita Haywood Wiltz, and my family is one of the oldest in Tamina. My family is a big part of Tamina with six generations who have made Tamina their home. As a matter of fact, ten members of my family still live here.

My great-grandmother, Mary Louise Williams, was part Creek Indian. Her parents, Laura and Wilson, had been slaves. "Aunt Lou," as we called her, told us they had been part of the house staff at the plantation and could read and write. Louise's daughter, Clara, married Willy Haywood. His forefathers were slaves on this land, but instead of picking cotton, they were the educators of the children, the readers, and the midwives.

I think it is because of this, the importance of education has been instilled in us.

Aunt Lou was the midwife in Tamina and not only delivered many babies but nursed many of the white babies too. She worked for the Grogan family who owned Grogan's Mill and for Dr. Falvey who was a surgeon in Conroe and had a summer home in Tamina. She always requested Sundays off. Out of curiosity, Dr. Falvey went to church with her. Tamina Tabernacle was in awful condition, and Dr. Falvey made the decision then to build the congregation a new church. It was named Falvey Memorial Baptist Church in his honor and built for the glory of God. It still stands today and is the church my family continues to attend.

Great Uncle John Elmore was Louise's brother. I remember helping him and his wife Marie in the grocery store turning buttermilk. I also remember Uncle John bringing back some men from Africa—the first Africans we ever saw in the community, and he wrote a book, *Where Do We Go from Here?*

We've a strong sense of community in this town. My mother and grandmother always taught us the importance of volunteering and caring for others, and I'm teaching my children to do the same. I started Children's Books on Wheels where we promote literacy through an after-school tutoring program.

You won't come into our community and not be offered a meal. You won't come into this community where we won't share our love and a smile with you. We'll invite you to share our faith and welcome you to our church.

We've been trying to preserve the history of this town and to keep Tamina on the map. Tamina was first named Tammany after New York's Tammany Hall. My great uncle, John Elmore, said they could never get the pronunciation and spelling right, so eventually, everyone seemed to settle on Tamina.

There is such rich history here. Once slavery was abolished, many found their way here either from surrounding towns, Louisiana, Alabama, or other freed slave states and made Tamina home. They found work in the logging industry.

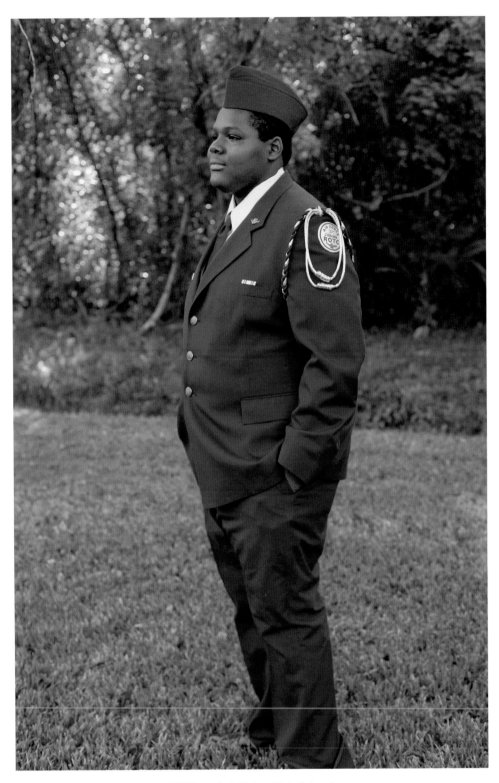

Jeremy Wiltz, Rita's son, is in ROTC at Oak Ridge High School.

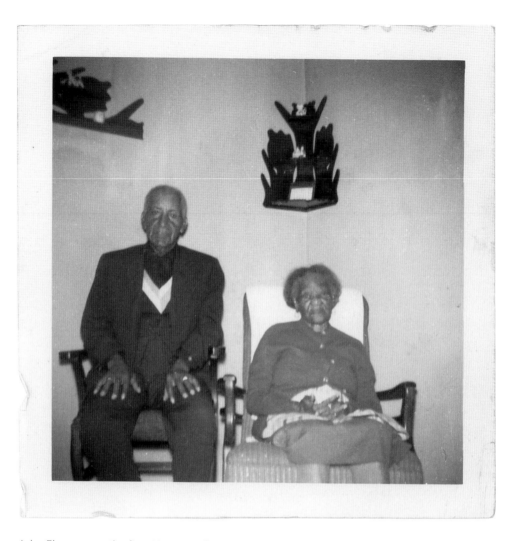

John Elmore was the first Negro mail carrier in Montgomery County. His sister, Mary Louise Williams, was a midwife in Tamina and for the Grogan family. They both lived into their 100s. *Photo courtesy of Wanda Horton-Woodworth*

Tamina was one of the few towns between Houston and Conroe. The towns you see around us now have only come into being in the past thirty to fifty years. Not long ago, the land that is now known as The Woodlands was our hunting grounds. My dad taught me to shoot and skin squirrels there. And the lake at the west corner of I-45 and Research Forest Drive is where my family was baptized. The areas that are now Oak Ridge North, Chateau Woods, and Shenandoah were hog farms owned by Tamina families.

Our town has survived almost 150 years, and I'm proud of the role my family has played in the rich history of Tamina.

"Family history is not always good news, but it is our news and our history in the making."

I'm Wanda Horton-Woodworth. Growing up in the rural community of Tamina, Texas in the '50s was a very happy and memorable experience even though it was filled with challenges.

Because my mom became single, I spent a lot of time growing up with my great-grandmother, Mary Louise Williams, whom I called grandmother. My real grandmother, Clara, died a month after giving birth to the twins, Della Mae and Clara. Louise took and raised the twins as her own. She was the motivating factor in my life. She instilled in me most of my beliefs, values, my devotion to Jesus Christ, and my curiosity in my family history. I lived with her until I was five or six, and then I went to live with my mother, Della Mae, but she remained an important figure in my life.

Thinking back on the values that Grandmother taught me about the church is that in spite of human frailties, it should remain a place of worship for broken hearts to mend.

Though Tamina provided a safe and nurturing environment, living in the country had a lot of disadvantages. I could not participate in after-school activities, because we lived too far away from Conroe where we went to school. It was the belief of most of my teachers that nothing good could come from Tamina. One teacher however, Mrs. Tommy West, believed in my potential and tutored me. Despite having a rural upbringing, my mother, Della, exposed me to a world I had never known existed— Girl Scouts, 4-H Club, opera, musical entertainment, the arts, and much more. When I was eight or nine, I started reading every piece of writing that was available to me about all sorts of things.

Joining the 4-H Club in the mid '60s was something I did not want to be involved with, but since my mother

Portrait of those baptized in the lake on what is now Research Forest Drive in The Woodlands. Wanda Horton-Woodworth is in this picture. She was eight years old. *Photo courtesy of Wanda Horton-Woodworth*

was one of the group leaders, I had no choice. It was clear we were not going to be treated fairly, because we were black. No matter how original our projects were, the judges always ignored our presentations. So, year after year my sister, Rita, and I continued to be active in the club though there were times I just wanted to quit. My mother continued the belief that God sees, and while we are trying to figure this thing out, God will succeed in working it out.

In 1969, the county extension agent advised all seniors to submit an application for a four-year college scholarship. I was not interested. After all, I always faced unfairness by most of the 4-H Club leaders. But at the insistence of my mother, I applied anyway. As I expected, the club chose a white girl, a friend of mine, as the recipient of the scholarship. The financial sponsor of this scholarship surprised me though. It turned out that Mrs. Bess Fish of Houston disagreed with the decision and told the committee if a scholarship was not offered to me as well, she would refuse her funding. As a result, my friend and I both received a full four-year scholarship to Sam Houston State University in Huntsville, Texas, where we both earned degrees and then became teachers. We lost our friendship during those college days. After all, it was soon after integration.

Shortly after attending Sam Houston in 1970, my grandmother, the woman who had been such an important figure in my life, died. No one in my family knew how torn up I was on the inside. I became focused on my family history. I attended most family parties, anniversaries—virtually any time the family was assembled, I wanted to be present.

Keeping the family together was a legacy Grandmother stressed. My cousin E. L. Edmond had been responsible for family gatherings until his death, and years passed since our family had an organized family reunion. In 1994, I called the family together in the old family community of Tamina. It was a success. Family members came from all over the country to attend. It seems like they were just waiting for someone to take the lead.

My focus now is to know more about my family, discovering where we originated, where we came from, and where we've gone, searching for photos.

Family history is not always good news, but it is our news and our history in the making. I continue to lead the family in reunions and feel it is now my legacy to gather the Elmore-Williams family.

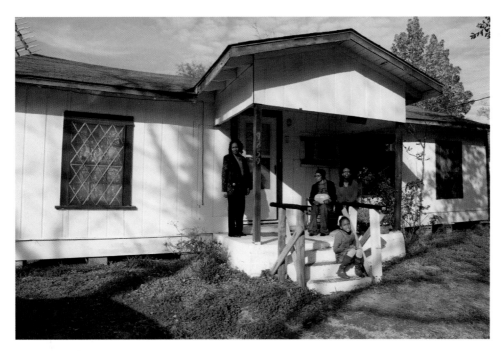

Four generations of Wanda's family on the porch of her mother's home: Wanda Horton-Woodworth, Della Mae Haywood-Henry, Delta Precious Woodworth, and Kayla.

"My family did not discuss racism during those days. They did not have to. We felt it."

— Wanda Horton-Woodworth

Wanda was baptized in this lake. The Woodlands now owns this land, and in 2015 the city filled the lake for the construction of a new office building.

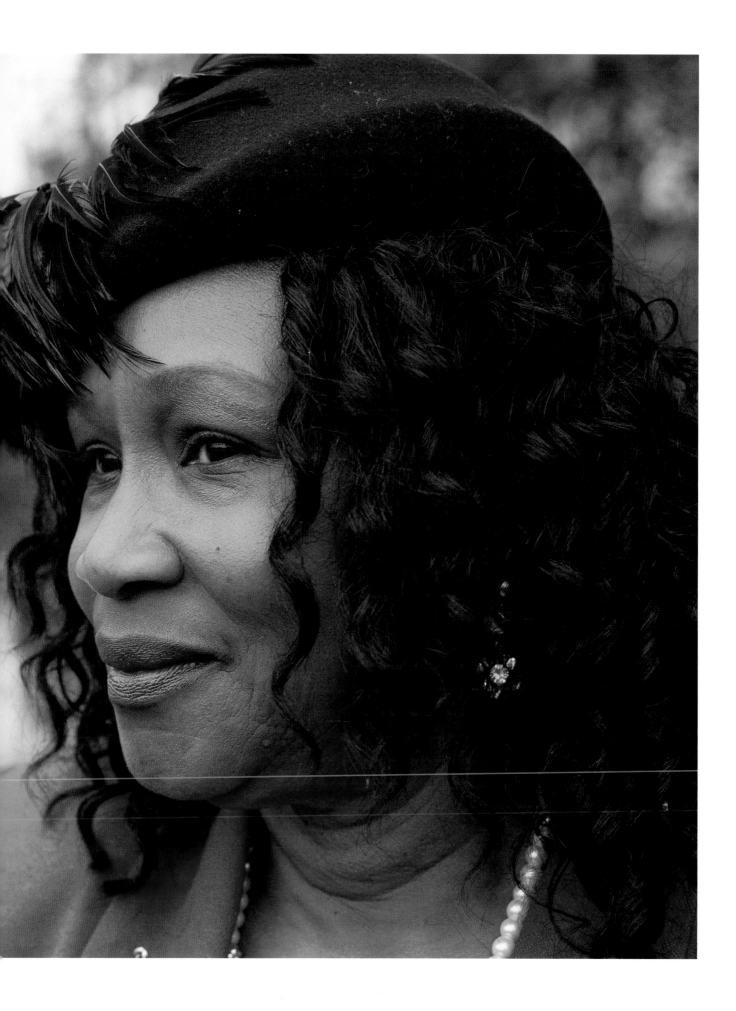

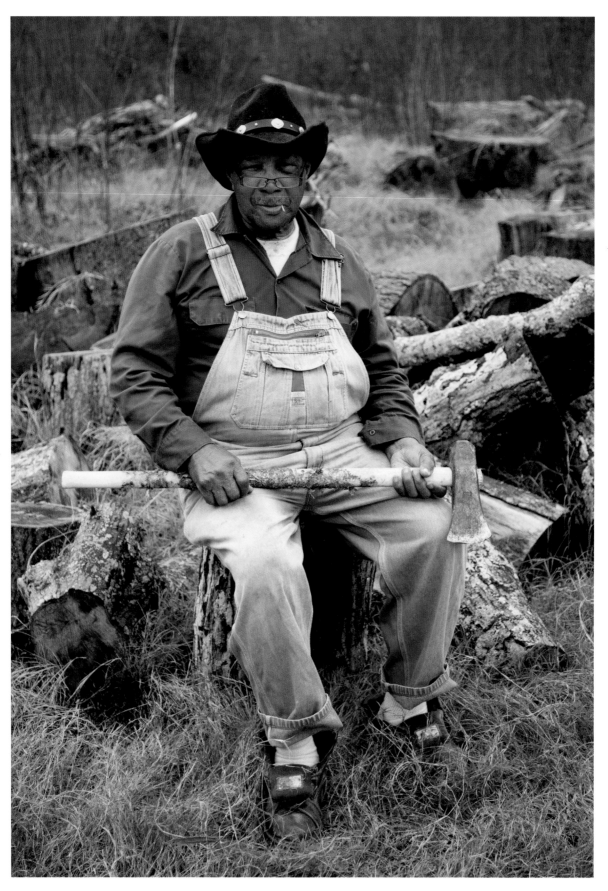

Joe Rhodes, forty-two years after the photograph was made by Marvin Zindler's team in 1970.

# The Rhodes Family

"Times sure could be real hard, and we had many hungry days."

My name is L. C. Rhodes, but everybody calls me "Joe." I was born in 1925 and I've been right here in this town since 1937. I can tell you some stories.

When my family came here, trees and bushes were all you could see. The houses were far apart, and there were no streets. We paid fifty dollars an acre for this land in 1939. I think my folks paid five dollars down. I remember helping my daddy stake off our property. Man, it was hard to come up with the one dollar each month to pay off the loan. Mr. John Elmore would sometimes help us make our payment, and we'd pay him back.

When I was young, I helped make money by chopping wood. We'd cut wood, haul it, load it in the car, and sell it in Conroe—all for twenty-five cents a cord. That's a lot of wood—four feet high, four feet deep, and eight feet long. Getting to Conroe was a challenge. You know, there were only three old cars in Tamina, two old Model T trucks and a Model A. We'd have to catch someone who owned one of those trucks when he was going into town on a Saturday morning. We'd get there about ten or eleven o'clock. After we unloaded the wood, we'd sit out there in the hot, hot sun waiting to be paid. You know, the blacks couldn't drink the white's water.

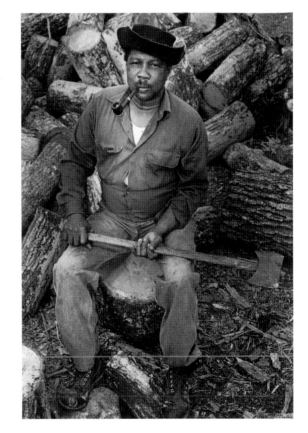

This photo was taken by Marvin Zindler's team, which came to help Tamina get a water system in place. *Photo courtesy of Joe Rhodes*

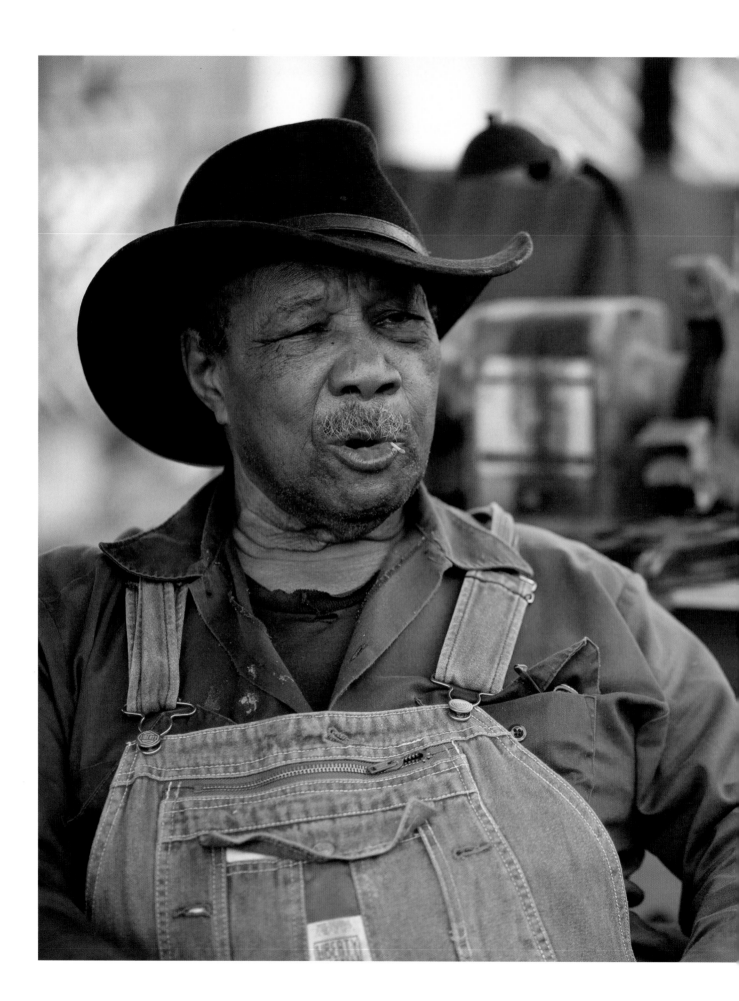

Joe Rhodes moved here in 1937 and has been here ever since. He has experienced the struggles of hunger and racial tension as well the strength of a bonded community.

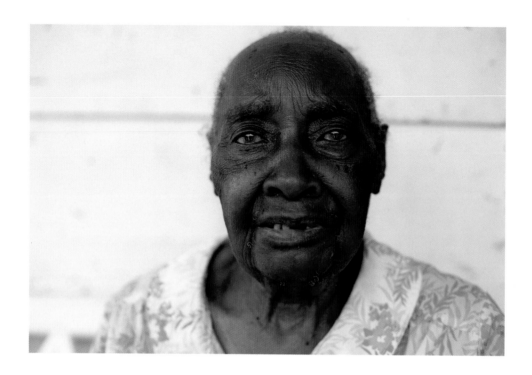

"My wife, Ollie, has brain cancer. Services have come and want to put her in a home. But we've been married sixty-seven years. I promised 'for better or worse' and can't imagine living my life without her."

—Joe Rhodes

We couldn't drink out of any faucet, and we sure couldn't ask white people for any. They'd sit up on the porch drinking their cold water though, knowing how thirsty we were. It was painful. And to make it worse, sometimes we were bullied. Still, we'd sit there until night came when they would finally pay us and we could go home. I never understood that.

Five-fifty a week, that's what we made cuttin' wood. And if it rained, we had no work. We'd cut four cords a day to make that dollar.

I married Ollie Mae in 1947. That's 65 years ago. We didn't have our own kids, but the kids in town sort of adopted us. I always had sodas for them, and Ollie Mae would make them dinner. There'd be times some kids would cry when it was time to go home. That made me sad, and we worried about them.

In the late '60s, the kids in Tamina started going to Conroe High School, but when I went to school, I went to a one-room schoolhouse here in Tamina. Sometimes a car would haul us to school, but we usually walked. It was just a mile or so away, but when it rained, we'd wade in deep water to get to class.

Tamina didn't get electricity until 1962. Before then, we didn't have lights. No TV. No radio. We didn't have any music. We didn't have an icebox or refrigerator, either. We had some cousins who would get us ice up in Conroe. It cost fifty-five cents for fifty pounds. We'd wrap it in newspaper and place it in a hole we dug in the ground and then cover it with leaves. It would last four or five days. Sometimes, the white folks would buy a new icebox and they'd give us their old one. We thought that was something, 'cause then we didn't have to dig that hole.

Getting water was hard, too. We got ours at the artesian well on Dr. Falvey's property. He brought a big pipe to the roadside from the lake so we all could have access.

My uncle worked for Dr. Falvey and was the caretaker of that land in 1935. After Dr. Falvey's death in 1948, the Schott family that owned a bread company bought the land. They added a hose to the piping and continued to provide the water to the community. Then, some trouble started. Sometimes, Tamina folks or others wanting to cause mischief would leave the hose turned on or steal the hose. The owners thought they didn't have a choice but to take away the hose. We had to count on the rain collected in our rain barrels after that.

Those in Tamina saved for years until we had the fifty dollars needed to get our own water system in place. We brought in Marvin Zindler sometime around 1970 to put pressure on the people to bring us water. It still took us two or three years to get it. If he hadn't come, we'd probably still not have water.

Times sure could be real hard, and we had many hungry days. Things were cheaper in the old days. Ten dollars would buy more groceries that you could use. It was getting the ten dollars that was the problem. The Schott family planted

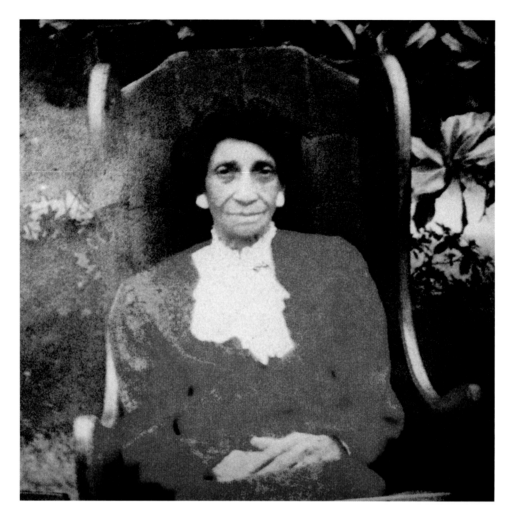

Ollie's mother, Olivia Pierson. *Photo courtesy of Ollie and Joe Rhodes*

peas around the lake. Sometimes we just didn't have anything to eat back then, so we'd pick those peas and put them in five-gallon jars. Weevils would get in there—those are bugs, in case you don't know. There wasn't anything else to eat. We were desperate. So, we'd cook them and strain them, mash them up. Shoot, they were good eatin'! We'd go hunting for rabbit and squirrels. And in tough times we'd even go hunting for armadillos at night.

I've been through some things, I can tell you. When I was fourteen years old we brewed whiskey, even though it was illegal. We made good money selling it. We'd cook up whole or chopped corn, sugar, and water in barrels. In the summer, it only took two days to ferment. In the winter, about a week. If we used wood, the "revenuers" (federal marshals) would catch us 'cause they saw the smoke. We got wise to it, so we started to use propane. We'd carry twenty-five gallon containers of propane on our shoulders from the store. We still got caught

though. After cooking the corn three times, we'd pour out the cooked corn to start a fresh batch. The horses and cows would find it, eat it, and then pass out.

We'd cook about seven barrels a week. It was dangerous to do. They don't want you bootlegging whiskey. The revenuers shot a boy right across the tracks. Two men rolled in and they shot him in the back when he ran away. We never brewed whiskey again.

When I was cooking whiskey, I never took a drink, but after that, I did some hard living. I never did any drugs, but I consumed some bourbon, and my problem was women. I done a bit of everything, but in 1980, I stopped smoking and drinking. I wouldn't have made it if I hadn't done so. I'm glad I never did hurt nobody. I can sleep at night with an easy mind.

Right now, my wife has a tumor in her head. They want to put her in a home. She's in bad shape, and that puts me in bad shape. But after 65 years, I can't see getting away from her. The Lord can take her, but that would be different.

I believe that if you done right, God will soften the pain and troubles.

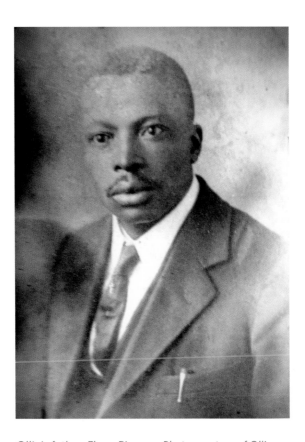

Ollie's father, Flang Pierson. *Photo courtesy of Ollie and Joe Rhodes*

Jane Gravis is Dr. Thomas Falvey's granddaughter, seen here in front of the Falvey homestead in Tamina.

# The Falvey Family

After building a summer home in Tamina, Dr. Thomas Seymour Falvey became entrenched in this community. His granddaughter, Jane Gravis, has discovered through her own research of Falvey's legacy that she has a strong connection with her grandfather.

My grandfather, born in 1874, was one of sixteen children born to Dr. James C. Falvey and Matilda A. B. White. All the children were raised in Texas, and four of those children became doctors.

One of those doctors was my grandfather. In the early 1900s, he was the first trained surgeon in Conroe and worked at Mary Swain Sanitarium, the local hospital. In 1936, he formed the Falvey Holland Clinic. After oil was discovered south of Conroe by George W. Strake in 1931, thousands came in search of their own fortune. My uncle was one of those and drilled for oil in Tamina. Instead of

Dr. Falvey spent his holidays on his property in Tamina. *Photo courtesy of the Gravis family*

The Falvey family land includes an artesian well that a relative discovered when drilling for oil. Dr. Falvey provided water from the well to residents of Tamina.

discovering oil, he struck an artesian well deep underground. It quickly created a lake. My grandfather heard about it, purchased the property, and built a summer house on that land. From that point forward, he became entrenched in the community, becoming the family doctor for the people of Tamina.

He threw parties and always invited all the residents of Tamina. My aunt remembers going to those parties. There were always babies being thrown up in the air and celebrated. I remember my aunt saying how scared she was when they were thrown so high, but the babies just smiled and laughed. Mr. Rhodes, a resident of Tamina, remembers Christmas services at the church. "When Dr. Falvey walked in, everyone would applaud and cheer for him. They loved him and were so grateful, because he would bring baskets of food, toys, and crates of sodas." He would kill a goat or a cow and throw a huge barbecue for them. He was always giving to this community.

Louise Williams, a Tamina resident, became the midwife for my grandfather. They became dear friends, and he built the Falvey Baptist Memorial Church in her honor.

Because of the artesian well, he also provided water for the community. There seems to be a spiritual connection between my grandfather and me. Fifteen years ago, I was invited to go on a mission trip to Kenya through my church. It was a hard decision to make, but after praying hard about it, I agreed and went with a group from my church and helped to build a well. I fell in love with the land and its people. In the following years, I was given land in Kenya and built an orphanage giving children the opportunity to be raised in a loving home. Because of a well we built, I was able to provide a spigot at the fence line of our property, providing water to all of those living in the neighboring village.

Dr. Falvey family members and boy from Tamina enjoy the lake by Flalvey's summer house. *Photo courtesy of the Gravis family*

It was not until recently that I learned about my grandfather's summer home and dedication to those in Tamina. He was helping an African American community providing their water, and for the past 15 years, I have been working in Kenya building an orphanage and providing water for that community.

I can't believe there is such a meaningful connection between my grandfather and me and am so proud to continue his legacy.

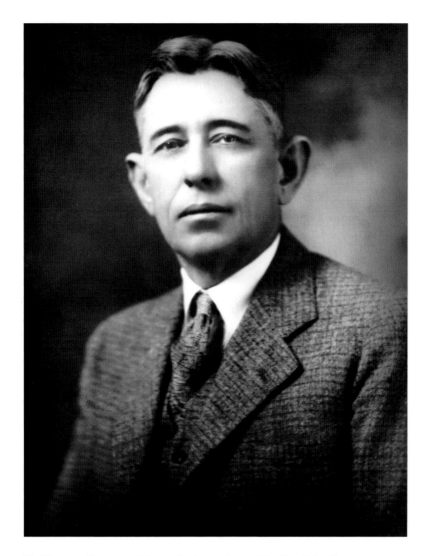

Dr. Thomas Seymour Falvey. *Photo courtesy of the Gravis family*

"I can't believe there is such a meaningful connection between my grandfather and me and am so proud to continue his legacy."

—Jane Gravis

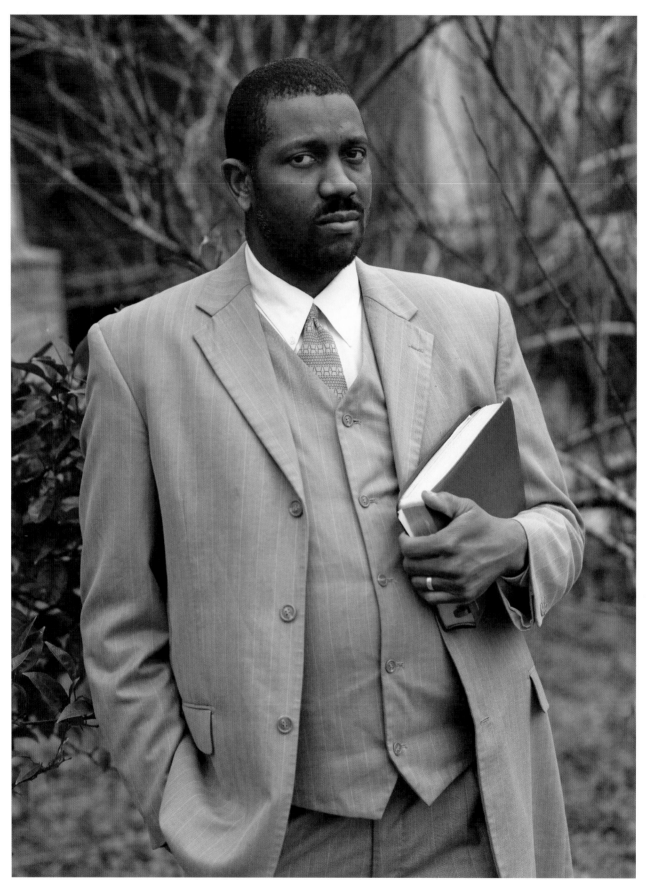

The Reverend Roger Leveston stands outside his mother's home beside one of her many fruit trees.

# Reverend Roger Leveston and the Faith of Tamina

"All are welcome around the dinner table, regardless of who they are. It's part of what gives us a sense of community."

My name is Roger Leveston, and I am an assistant pastor at Falvey Baptist Church.

My grandfather was the first one in the family to move to Tamina. He even has a street named after him. I was born and raised here. The only time I moved far away is when I spent four years in the Navy. Even though I reside in Spring now, I still consider Tamina my home and always will.

I'm an assistant pastor at Falvey Memorial Baptist Church, where The Reverend Ginns has been the pastor for more than thirty-six years. Faith plays a very large role in this community. When I was a kid, I noticed that when somebody was drinking beer, they threw it away when they got close to a church. If they were smoking a cigarette, they put it out. Churches were holy ground. They were sacred.

Churches are still important here. I have to laugh and say that Tamina has almost too many churches. We have two Baptist churches, one Church of God in Christ, one Church of Christ, and we have one Full Gospel Church. That's five churches and they all make up a family, you know? I wish we could have one big church, where we could all gather. When somebody real popular dies in the community, we've got to go all the way to Conroe to have the funeral, because we don't have a place big enough here.

Churches show what community is in Tamina. Even our young people know that. Young Jemanece Ginns, the granddaughter of our pastor, says it nicely: "My mama, she's good, and she is gentle and helpful. In church, she helps a friend pass out turkeys to the homeless. She prays, and she reads the Bible." That's the truth of Tamina. I can remember the people who used to come to my mom's house around dinnertime. I remember two young guys who came by and they said, "We're such and such grandchildren, and we're hungry." She didn't hesitate. She invited them in and fed them. The sense of community and caring for one another is one thing I can always count on.

To me, Tamina is one of the best places to be raised. Tamina is where good and gentle people do God's work inside their churches and in their everyday lives.

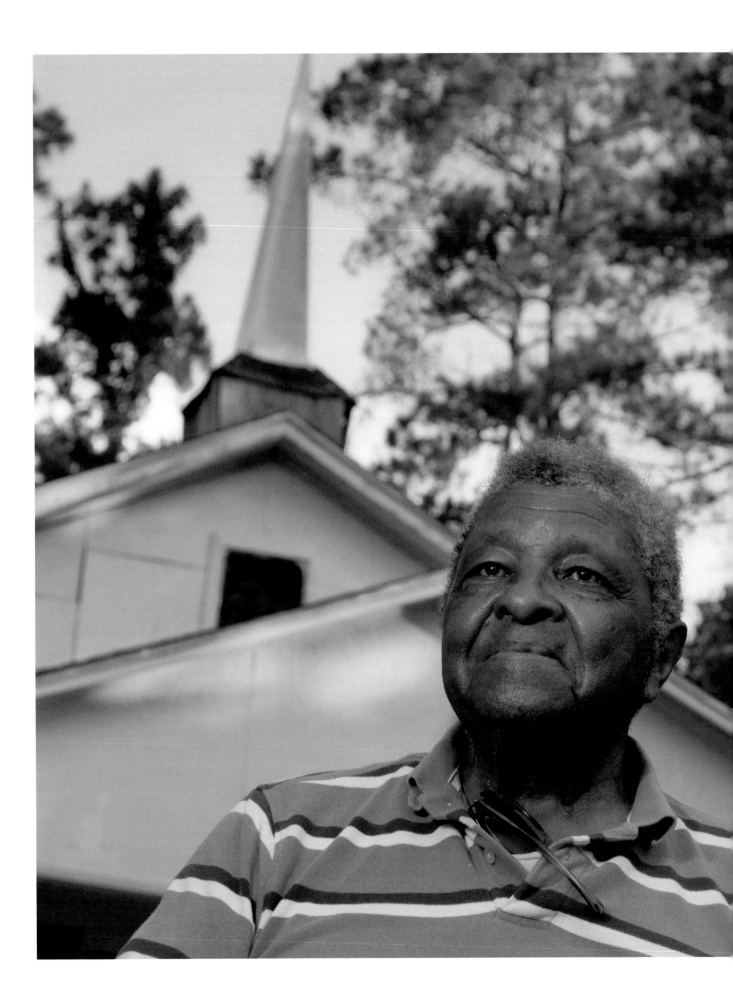

The Reverend Elvin Ginns built the steeple of the Falvey Memorial Baptist Church, and was the pastor there from 1976 until shortly before his death in 2014.

Full Gospel Holiness led by pastor Ernest Mills.

"Churches show what community is in Tamina."

—The Reverend Roger Leveston

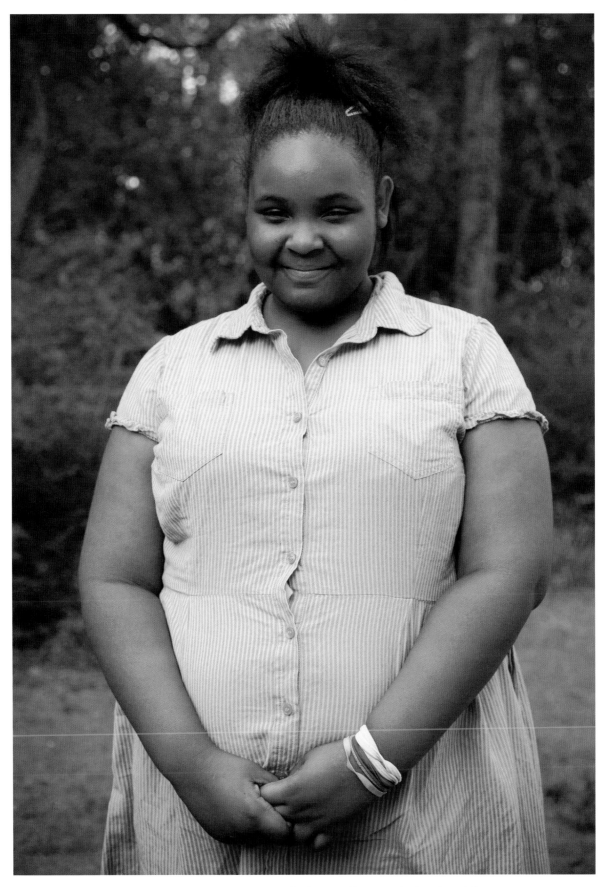

Jimaniece Ginns, Rev. Ginns's granddaughter, has a gifted voice. She attends church with her sisters and mother and sings in the choir.

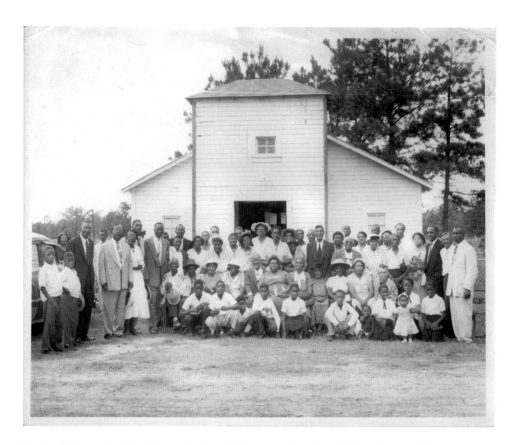

Tamina Tabernacle Church eventually split into two churches: Falvey Memorial Baptist Church and Lone Star Baptist Church. This photo shows the congregation in front of Lone Star Baptist Church with the Reverend W. J. Jones (pictured far right). Image taken approximately 1956. *Photo courtesy of Wanda Horton-Woodworth*

"Tamina is where good and gentle people do God's work inside their churches and in their everyday lives."

—The Reverend Roger Leveston

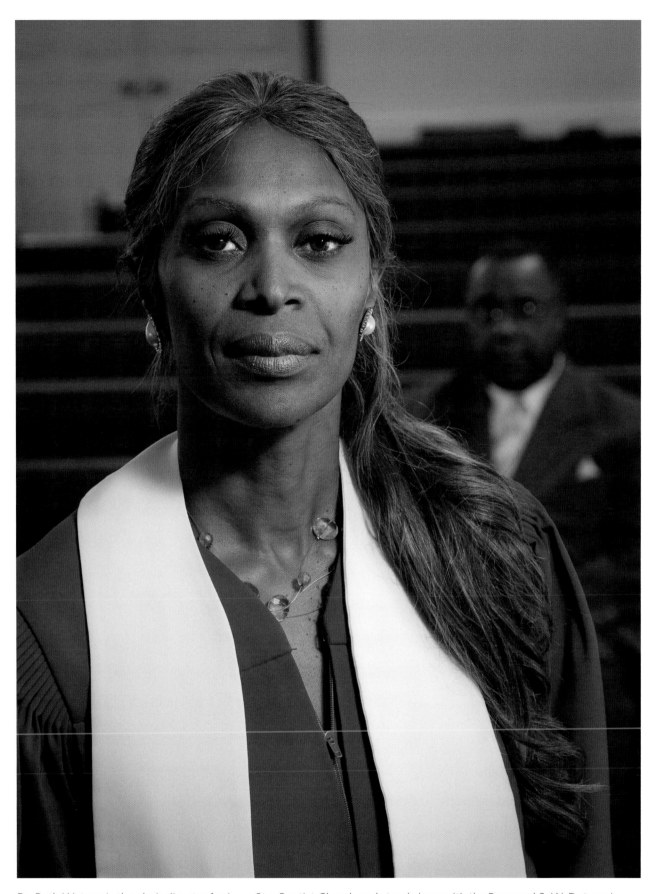

Dr. Ruth Watson is the choir director for Lone Star Baptist Church and stands here with the Reverend S. W. Dotson Jr.

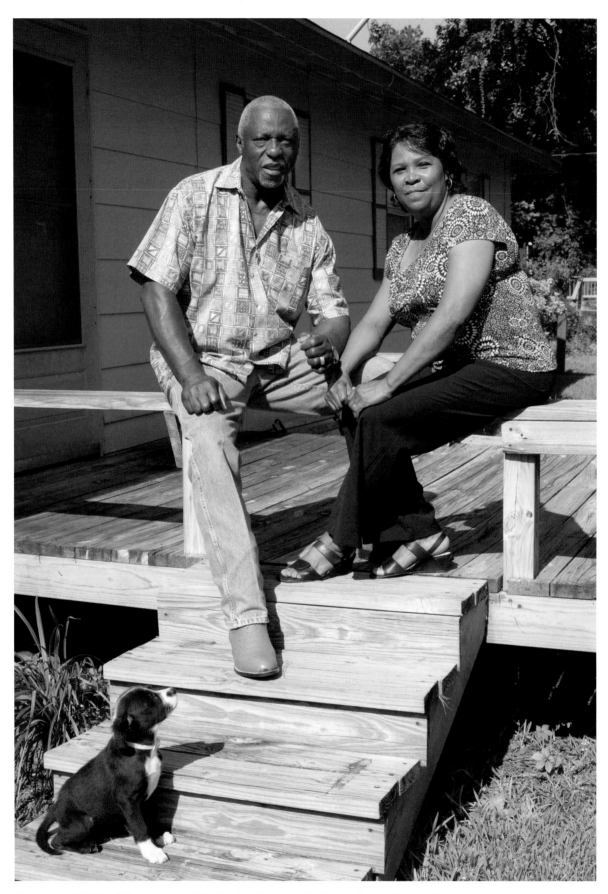

Ranson and Shirley Grimes opened the Tamina Community Center to provide a safe learning environment for children in 1998.

# The Grimes Family

"Every day, I tell the kids there's no 'me' without 'you' and no 'you' without 'me.'"

I'm Shirley Grimes. I first lived in Tamina as a little girl.

There's a scripture in the Bible that describes how I feel about Tamina. It says, "Every place on which the sole of your foot treads shall be yours."

Sunday mornings are what I remember best about living in Tamina as a girl. I would walk down a dirt road to a white church. I always found comfort there, and that white church stayed in my mind even after we moved to Houston. Later, after I moved back to Tamina with my husband, Ranson, and our children, we wanted to build our own house. Someone said, "You remember that old church? They're tearing it down and selling the property." Well, we bought that land, and my house stands exactly where the church once stood. So, there it is. When I go home, I can walk the land that was so important to me as a girl. I feel blessed to have grounds that are holy and were designated to God. And God has given it to me. This is where I am supposed to be.

I am here in Tamina because I never wanted to break my family chain, my community chain. Where my parents moved, I moved, even after I was married. We have always lived only a few minutes from each other. Ranson and I came back to Tamina in 1974 so I could help my father after his legs were amputated. When we bought that old church property, Daddy lived on the back side of the land in a mobile home we bought for him. Later, we bought the property next door, and when Daddy died, the mobile home was used to establish the Tamina Community Center, where we first offered after-school programs for the young kids in the neighborhood.

The Community Center has grown. It's all about serving Tamina to keep it strong. Education is very important to our children. We have renovated and expanded it to offer childhood-learning and after-school programs. Of course, we teach black history in the Community Center. The newest addition includes a classroom for toddlers filled with stuffed-bear animals. We look forward to

having teachers brought in to create a good learning environment. We have new office space, too. I can meet clients and parents and have a private conference. We needed space where kids could visit privately with counselors or with Child Protective Services. Those meetings can be scary for kids, and I don't ever want kids to go through fear. We also have built an exercise room for the children and the elderly in the neighborhood to come exercise and hear talks on health and nutrition.

It's because of the generosity of those living in the surrounding communities and grant rewards that we have been able to sustain and grow this center.

I keep a picture on the wall that reminds me of my grandmother and mother. Their pride and joy was their children. This picture says, "Children are important." My philosophy is, if you have children, especially small children, make sure they are safe, and that their day is livable.

I'm proud of the Tamina Community Center mission: To improve the quality of life through education, programs, and activities for people with emphasis on unity, self-determination, collective work and responsibility, cooperation, economics, creativity, and faith. Every day I tell the kids there's no "me" without "you" and no "you" without "me." That's how my family has lived. That's how Tamina has stayed a community all these years. We're in this together. We have to be responsible for each other. This has all been a lot of work, but it's exciting and points to a good future for Tamina. That's the number one reason I get up every day.

"When I was a little girl, I attended a little white church that was once on this property. It was a place where I found comfort. And now, I have built this center on the same piece of land. It is built on sacred ground."

—Shirley Grimes

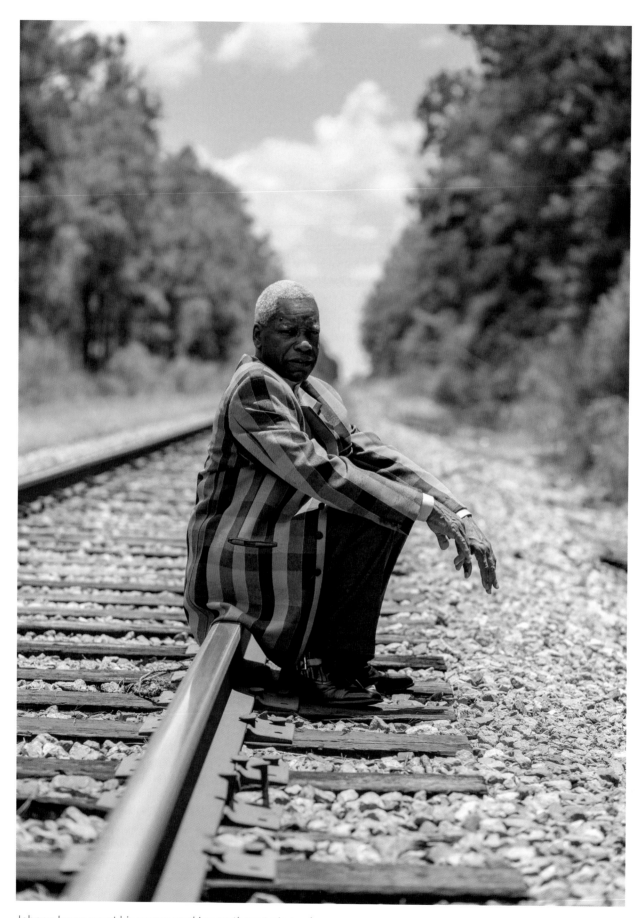

Johnny Jones spent his career working on these train tracks.

# The Jones Family

Whether singing in a choir or playing keyboards on stage, music has always been his passion.

I'm Johnny Jones, and I was born March 21, 1945. My family lived in Midway throughout the week and then stayed in Tamina on the weekend.

My dad worked for Dr. Herbert T. Hayes, farming for him, maintaining his property, and helping with other chores. Patrick Hayes, Herbert's grandfather, had purchased the land in the 1830s and founded three plantations.

It seemed like every Friday night, there were parties at the Hayes' home. He was real rich. He would invite those that owned the gas company and electric company and people that came in town from overseas . . . rich folks. Me, my brothers, and sister would have our white coats on and serve drinks, and my dad was the bartender. I was four years old when I started doing this. My mother was the Hayes' family cook. She'd cook dove and squirrels. Sometimes she would take a cow head, wrap it up, bury it in the ground with coals, and cook it all day to serve for a party.

Dr. Hayes treated my dad and family real good. He gave us all our shots. We had a house on his property in Midway and one here

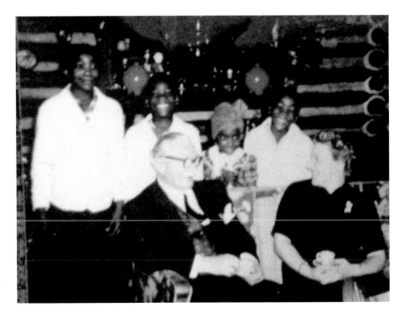

Johnny, the second from the left, helped serve during Dr. and Mrs. Hayes' parties with his brothers and sister. *Photo courtesy of Johnny Jones*

in Tamina. The only thing I remember having to pay for was our family car. He paid for everything else. He took good care of my dad and mother.

My dad, Will Jones, was also a reverend. He was known 'round everywhere. He preached at Lone Star Baptist Church the second and fourth Sundays and then was up at Conroe, at Jones Chapel Baptist Church on the other Sundays. They loved his preaching. He was the reverend at Lone Star for fifty-some years. We had to go to church all day Sunday and then Sunday night.

When we moved to Tamina permanently in 1957, he had a business mowing lawns, baling hay, and cutting wood. We worked with him after school let out and all day Saturday.

I went to high school at Booker T. Washington during segregation and graduated in 1965. A year later, the schools integrated, and everyone began going to Conroe High School.

When I started going to Texas Southern University (TSU), the civil rights movement was in full force. It created a lot of tension while I was in college. Demonstrations were going on through that time. There were meetings, rallies, and discussions about getting better jobs and pay. They marched, but they did it right according to the rules, always marching two by two to downtown. I marched one time. It was scary. Having to march two by two to be sure to be legal, you felt exposed. Fortunately, there was no violence.

I studied industrial education and majored in electronics. During the school break in 1969, I was drafted in the Army. I went to Fort Bliss for my basic training. I was based in Fort Huachuca in Arizona first, and then I spent eighteen months in Germany. I was a supply clerk and then a managing clerk. When I returned, I didn't go back to school. I felt it was time to get to work. I worked on the railroad during the day and played music at night.

I started playing piano when I was small. My dad taught all of us. Then, we had music lessons at school, and I sang in the choir. When I came home from college during the Christmas holidays, I played with my brother and Lonnie Pitts, who I grew up with. They had guitars, so I got me a keyboard. We were all interested in music. We practiced and played until we finally all got into the same key. We didn't know what key it was, but we were afraid to stop. The three of us put together a band.

Our first show was in Tamina in a café. It was crowded, and we were scared. My, we were scared. But people kept encouraging us. We could only play three songs. We'd play the first song, then the second song, then the third. Then we

The band Exit recorded a mania song celebrating the Houston Oilers going to the Super Bowl. It sold well until the Steelers won the game.

"I spend my time singing and recording Gospel music now that I've retired."

—Johnny Jones

looked at each other and asked what we should play next. We just played them again and again. Those people put up with us all night long.

Molly Brown's daughter, Jocelyn, used to sing with us. It was hard to get her off the stage 'cause she loved to sing so much. You had to cut the lights out to get her to stop. We played in Navasota one night and she sang, "I'd Rather Go Blind." There was a man in the audience who stood there and just started crying. She was so good.

Then, we started the 58 Engineers that then became Exit. I played the keyboards. My brother played the guitar. Clennis High, who also played with Archie Bell and the Drells, played the guitar too, and was our lead singer, and Barry Bland played the saxophone and trombone. He had played with Tina Turner. We also had different back-up singers.

We worked during the week to pay our bills but played nights and weekends. We played everywhere in Texas and Louisiana. We played for hotels and radio shows. We were treated like celebrities—even got asked to sign autographs. One night when we were playing in a club, two young ladies came up all excited and said, "We've never been beside any stars before." And I thought, "Me either." But I had to go along with it. I thought to myself, "They have no idea that come Monday, I'll be working on those railroad tracks."

We worked real hard, envisioned we would make it big. I had set a goal I would retire at 35. I have to laugh at that now. We did try real hard to reach that goal, though. The first song recorded was a funky soul song called "Funky Fly," and then we wrote other songs that got radio time.

Well, I retired at 62, not 35, in 2007 from Union Pacific Railroad. I'd been a track foreman and track inspector.

I'm not playing anymore in the band. I spend my days singing in the choir at the Falvey Church and recording gospel music with Clennis High.

My mother gave me this half acre, and she gave my brother the other half acre of our family's land. I own this, and this is where I plan to stay.

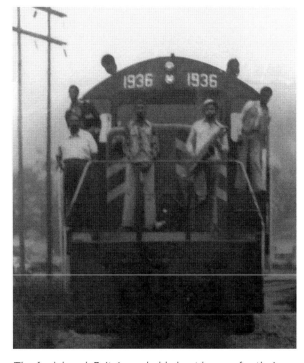

The funk band, Exit, is probably best known for their release, "The Little Green Monster." *Photo courtesy of Johnny Jones*

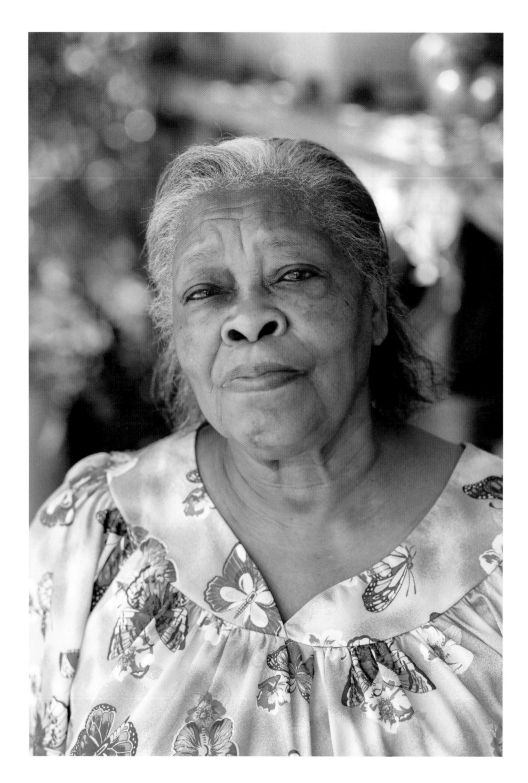

"Whenever there's a tragedy or sickness, we all come together.
We help one another in this community."

—Molly Brown

# The Brown Family

The prejudice we have felt "might be one of the reasons we are such a close community."

My name is Molly Brown and I've been here all my life—that's been 74 years.

I was born September 7, 1938.

Tamina was once a big place. Back when I was a little girl, it went all the way north up to Minnox, east to the San Jacinto River, all the way west to Magnolia, and south to a little place called Halton, which was just shy of Rayford. There was a sawmill on this spot on Tamina Road before I was born, way before the Grogans came here. We used to find pieces of iron from that mill.

I haven't always lived in this home, though I've always lived in Tamina. Once freed from slavery, my grandfather's family moved from Maryland, and my grandmother's people came from Arkansas. They first settled in Montgomery and New Waverly, but wherever the sawmill work was, they would follow. And that's how they found their way to Tamina. Most of the people living here then were black or Indian.

My first memory was living in my uncle's one-room shack right up the road. I lived there with my uncle, my mother, two sisters, and my grandmother. My grandfather had moved on. I remember my grandmother telling me she got tired of always moving and decided to stay put while he moved on.

Our house and Miss Wheeler's motel and café were the only buildings on this street. The roads were made of dirt, and this area was nothing but woods. No electricity. No running water. We got our water from the artesian well on Dr. Falvey's property. My mother said he wanted to pipe water to the townspeople of Tamina, but they turned down his offer. I think the people here have always been suspicious of such offers, because they're afraid of their property being taken away.

There were probably 25 or 30 kids that went to the Phyllis Wheatley one-room school. We went there until we were promoted to the seventh grade. I remember there was a kitchen in the school. Sometimes the older kids would help the

younger kids, but we trained ourselves to cook in that little kitchen. There was one teacher who taught first through sixth grade. Her name was Annie Jenkins. My mother went to that school, too. She was living in Rayford when she was growing up, and Mr. Jenkins would bring her to school.

I remember we would line up to get our shots from Dr. Falvey, and then we'd sing Negro spirituals for him in thanks. He was a very, very good person. Even if you didn't have money, Dr. Falvey would help you. He was a great asset to this community. He had a church built for Tamina's people. It's named after him—the Falvey Memorial Baptist Church. He had picnics on his property and we were all invited, and every 19th of June, he'd have a big party and would hand out food and drinks to all of us.

Eventually, they put down the gravel on those dirt roads, and then black top on a few, and every now and then, you'd see a car. We learned to ride our bikes out there. At night, we'd lie on our backs on the road looking at the sky. Some of us even fell asleep out there. I remember the shining moon and starry nights. It always seemed so light at night. We had no electricity when I was little, so the stars were brilliant.

The trains carry a lot of memories, too. There was a switch here where the train would back into. The men would bring the cordwood and load it onto the train, which then went down to Houston. There used to be a big house right across the track that was L-shaped with a sycamore tree in the courtyard. The Blairs lived there and were in charge of getting the mail. They were a white family. I used to play with the little girls, Juanita and Charley May. A bag of mail would hang on a pole beside the tracks, and then someone on the train would collect it as it passed by.

If we wanted to catch the train, we just had to flag it down. The train would blow to let us know it saw us and would slow down and stop for us to get on.

Everybody was real close when I was growing up. If one person killed and cooked a hog, everybody had a piece of meat. We grew and raised our own food. We had chickens and hogs penned up, and the cows and horses wandered freely through town. It was just good here. You didn't even have to lock your doors.

We were all kind with each other. My mother taught me to treat everyone right. "You never know who, down the road, you're going to have to turn to. You treat people the way you want to be treated. If you do, you'll be respected."

In the '60s, many of us did café work in Conroe. We couldn't go into the bathrooms, and we could only drink out of certain water fountains. I remember going to the courthouse and seeing signs for coloreds over the water fountains, "Colored Women" and "White Ladies." We had to go into different stores, and when we did buy something, they'd throw us our change.

In '60 or '61, when I started working at the hospital in Conroe cooking in the kitchen, we could go into the cafeteria to clean up, but we couldn't eat there. We had a little space by the back door to eat our meals. It gets next to you, you know? We should have had those rights. They were really cruel in their time when I was growing up. The Lord delivered us from all this stuff, though.

When the laws changed, my kids had a hard time going to the integrated school. Even today, there are those that still have a bad attitude towards us, but we go on, we learn how to cope with it. It might be one of the reasons we are such a close community.

Sadly, I don't feel as safe as we used to. I think it's because people are coming in and out. Maybe it's because of the growth around us—The Woodlands, Shenandoah, Oak Ridge. It all has just nibbled away at the serenity of it all.

We're still a tightly-knit community, though. Whenever there's a tragedy or sickness, we all come together. We help one another in this community. Melvin Comeaux was riding his bike on the side of the road last week and was hit by someone, leaving him paralyzed from the neck down. They hit him and left him on the side of the road. The patrolmen think they have the person responsible, but they're still investigating. We'll all help where we can. It hurts to think that someone would do this and leave without going out for help.

To this day, we have no sidewalks. About five years ago, we heard the roads were going to be widened and sidewalks would be put in. Money went to fix up David Memorial, the nearby road going down to the new football stadium, but nothing's been done here. The kids have to walk to school and a lot of people walk to work. They all have to walk on the street. It's real dangerous especially on Tamina Road and Main Street. Cars and trucks go by too quickly. I wish people would drive more slowly.

I see signs in neighboring towns that say, "We love our kids." Well, we love our kids, too. I love all kids, no matter what color. I hate to see anything cruel happen to anybody.

Tamina was a good place to grow up back then. Now, we're just a little strip of a town.

Molly remembers horses walking freely throughout
Tamina in her childhood.

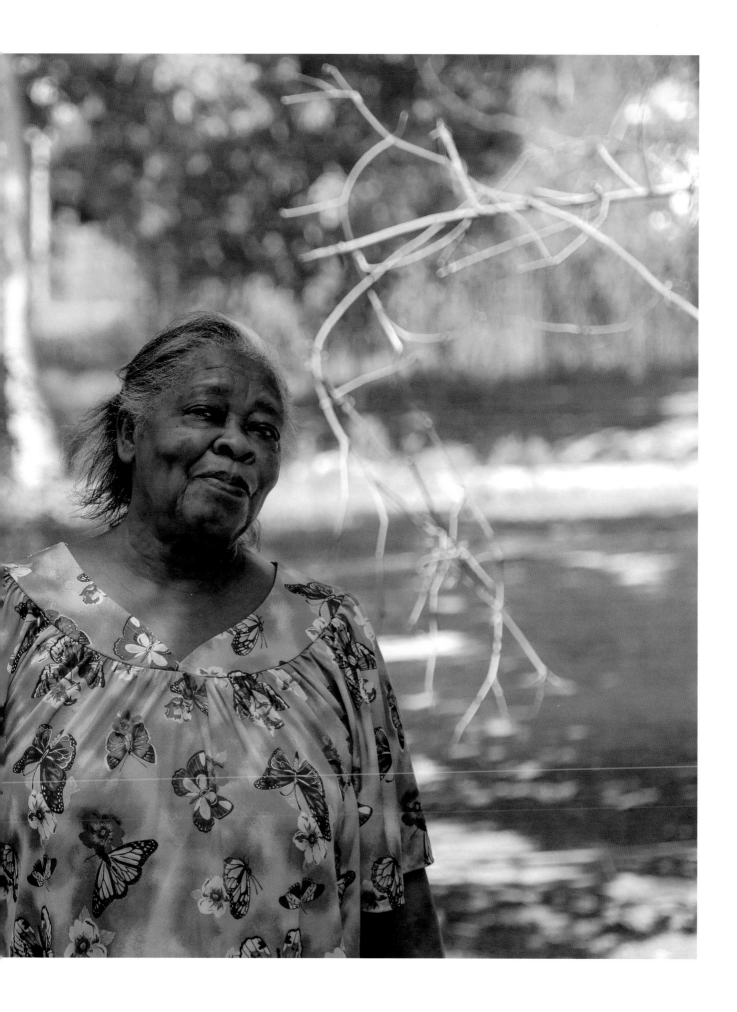

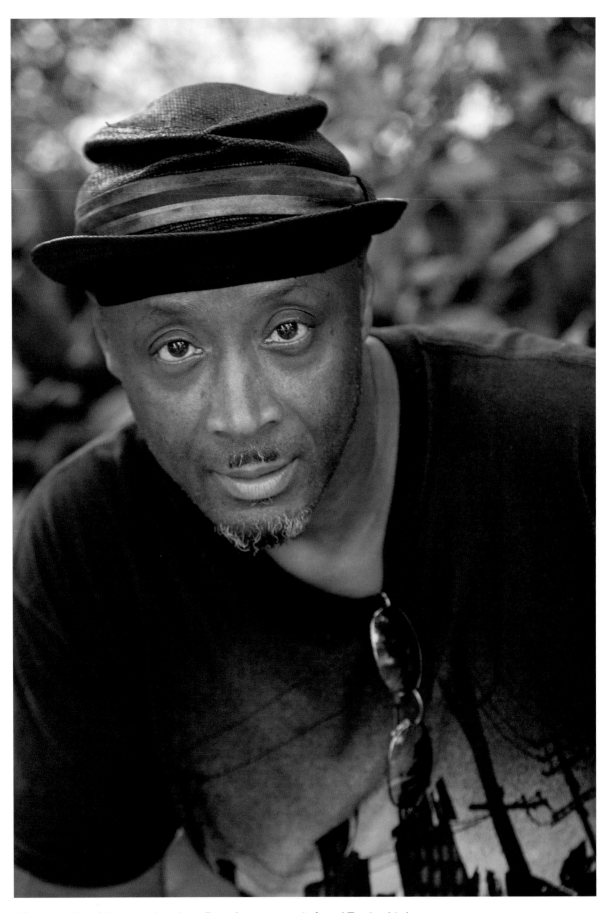

After spending thirty years in prison, Dyon has once again found Tamina his home.

# The Durst Family

Dyon is a descendant of the Pierson family, one of the first families to establish Tamina. He talks about a darker side of Tamina—gangsters, brothels, and drugs. After spending thirty years in prison, he's searching for a new path.

I'm Dyon Durst. I have a different story to tell showing another side of Tamina. It's my truth.

O. T. Pierson was my grandfather's brother. Like Boss Hog from *The Dukes of Hazzard*, he was the law in Tamina. When I was young, I watched people shoot and possibly kill others from neighboring towns. When that happened, O. T. made sure evidence vanished. There'd be no case. No one went to jail.

My father was a lot like O. T. You could say he was rowdy, and I was raised to be that way, too.

My story, I guess, begins when I was five. When the kids from my generation started going to school in Conroe, there was a lot of hatred aimed towards us. It wasn't because we were black, 'cause there were other blacks at that school who weren't treated the same way. Maybe they thought of us as intruders being bused into their city.

I remember a day when I was in kindergarten when they were taking class pictures. I was mad people treated us so badly even though they didn't even know us. So, I thought to myself, "If everyone is going to peg us as outcasts, we should act that way." So, I told our gang of six kids from Tamina not to smile, and not one of us did.

Not too many years later, I had a coach up in Conroe who pulled all of us from Tamina into a room. He called us "thugs." Can you imagine? We

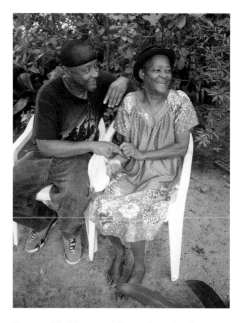

Dyon with his mom, Rose Dunst, sits outside in the garden she tends.

were just kids in sixth or seventh grade. "You ain't nothing," he'd say. I still can't understand how a coach could treat kids that way. We felt like it was us against the world having to go to school in an environment like this.

In order to survive in school, we had to put on a shell, and every day, there was a fight. I know this is a different story than you've heard about Tamina, but what I experienced was its street life. I wasn't raised like most people in Tamina. Most belonged to the church scene, but I never gravitated towards church. I was raised to live in the life of the cafés.

Before I became a teenager, my great-grandmother opened a house of prostitution. She bought all the land where my mother lives today, and the area around it, on the west side of the railroad tracks. She built a little café with rooms behind it, like motel rooms, and she brought females with her from Houston to do "the business" in those rooms. Her brothel and café catered to all the men working in the sawmills in the surrounding areas.

When I was seventeen, I thought I had so much money from selling dope. I was sitting outside a café counting my money. I only had like $800, but it was a big bank in my teenage eyes. So, as I'm counting, I'm thinking that the reason for school is to be able to go out and make money, but here I was already doing just that. So I quit, two weeks before graduating. I was just a teenager and didn't know any better.

I moved away from Tamina when I was eighteen, and a few years later, I found myself in prison . . . for thirty years.

My childhood was filled with chaos, but when you do thirty years in prison, especially for a crime you didn't do, you're doing all you can not to go back.

So, I've changed my ways. I got my G.E.D. in prison, and then I spent my first three years, after my release, going to Lone Star College. Since then, I've been trying to get some jobs, but it's not happening. It's hard to get a job when you have three Xs on your back. One, I have no work history. Two, I'm fifty-four years old. Employers want people that are going to be there for the next twenty years, not die in the next twenty. And the third X is the color of my skin. It's hard to get around those Xs. Even though there are organizations that hire ex-cons, I don't qualify since I did so much time. I won't let it keep me down though.

There's a program called Tuesday Night in Tamina, and I volunteer there mentoring the kids. I think the kids in Tamina these days have it better. They get to interact with different people and cultures at their school. Of course, there are some kids that show signs of following my childhood path, so I give them a scared-straight speech. I think it helps them.

What's in my future? Some say I should become a counselor. The kids listen to me. I could do that.

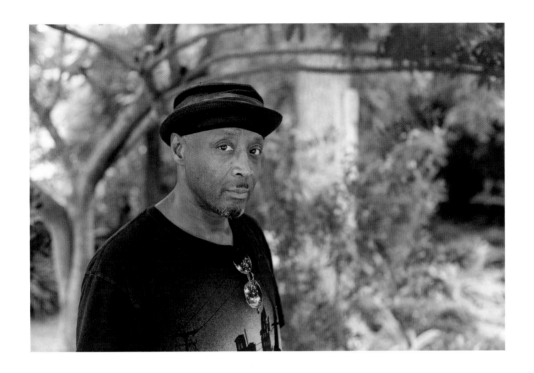

"My hat represents me. It's old. It's battered. It's beat down. When I do better, I'll get a new hat."

—Dyon Durst

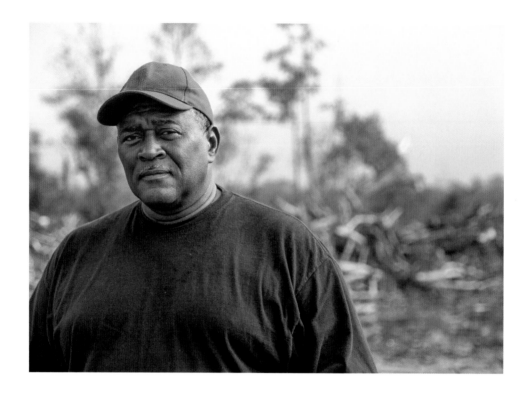

Andrew began working in the tree industry in his twenties, carrying on Tamina's legacy.

# The Robinson Family

The tree industry has always been a part of Tamina's history. Andrew Solomon Robinson has continued this legacy making tree cutting his living. The elders in this community were his teachers.

When I think back to the time I first moved to Tamina, I remember an active community. While I recall a still or two in operation around town, many black people were in the tree industry—tree cutting, pulpwooding, and logging. Working with trees and wood is how I've made my life here.

My family moved here in 1969 or 1970 when I had just finished the ninth grade. We really couldn't afford living in Houston, and we needed to find an inexpensive place to live. My dad didn't make much. He was the sole income earner and couldn't read or write. He and my mom met, among other people, Mr. Dennis Miller, who lived in Tamina. As a result, we came up here, and my folks fell in love with the place. We found a cheap house to rent, and we've been here ever since.

I went to Conroe High School soon after the schools were desegregated. For me, it was a pretty smooth transition. When I was a kid, we used to move around a lot. When we lived in Stafford, I went to Dallas High School. It was racially diverse—predominately white, but some black and Hispanic. We may have been viewed differently in Conroe because our community was a bit poorer than those in Conroe, but I didn't have a problem blending in.

When I graduated from high school, I moved into Houston and attended Texas Southern University. I studied political science with aspirations of becoming an attorney at law. After two years, I got a job working at Hughes Tool Company for the summer and made what I thought was a lot of money— significantly more than I was accustomed to. I worked overtime and weekends. Initially, I decided not to go back to school and to instead work during the next semester. When I tried to go back at one point though, it didn't take.

Eight-and-a-half years later, I got laid off and moved back to Tamina. I started working for a guy named Victor Neverson. He had his ropes, chain saws, and

climbing gear in the trunk of his car. He needed help, so I took my truck that I got from Hughes, he'd cut the tree to the ground, and we'd haul it back to my place. I had low land, so we formed burned piles. We would sell the logs and pulpwood and burn the trash to fill up my swamp land. That's how I got into this business. At the end of a day, he would make $1,000 or $1,200, and I would make around $150. It didn't take long for me to realize that I wanted to climb—both literally and figuratively speaking.

One day Victor broke his arm, and he needed someone to climb up a tree. He talked me through the entire process. When I reached the top, I knew I had found a way to support my family. So, I bought my own chainsaws, ropes, climbing gear, and an old tractor, and went from there.

The names that I initially came up with for my business were ridiculous. When I was at TSU, I spent a lot of time at the rec center playing chess, and the guys there started calling me King Solomon after my middle name. I certainly wasn't implying that I was the real King Solomon; rather it was a connection to my love for playing chess. The name stuck and became the name of my business.

I had a lot of help from the community. There were several of the old guys in Tamina who were in the logging and pulpwood business. I was greatly helped by Mr. Willie Leveston, Mr. Joe Rhodes, Mr. O. T. Pierson, Mr. John Randall, Mr. Burl Foland, Mr. Bill Beal, and many others. Most of them are gone now, but they will always be alive in my heart, and I will always be grateful to them. Sometimes they needed someone to climb to the top of a tree, top it, and block it down. That was my specialty. If the tree was too tall, too close to a house, leaning the wrong way, they sometimes called me to help them out. On my own jobs, when I took down trees, they would come and take the pulpwood, which blessed and helped me. They had climbers that I watched, and they coached me—taught me how to cut the notches and the pitches and how to throw trees. Once I learned the skills, they used to say, "Andrew, you can throw a tree on a dime and give us nine cents change." I was a good climber.

Twenty years ago, I was in an accident cutting down a tree and was rushed to a hospital. They told me that I almost died. God was looking over me the entire time and didn't allow that to happen. Anyone else taking a fall like that would have died, I think. I was on top of the tree and tied it off and then dropped down maybe 30 percent of its length. I saw it was really hollow, so I told my guys to pull on the rope to direct the top, but it broke off under my spike. I fell maybe thirty-five feet onto a pile of bricks. Now, I didn't fall out of the tree—never have. I was still in the tree when it landed.

After a couple of surgeries, I was back up in trees two weeks later. I had no other way to make money, so I started climbing again for financial reasons.

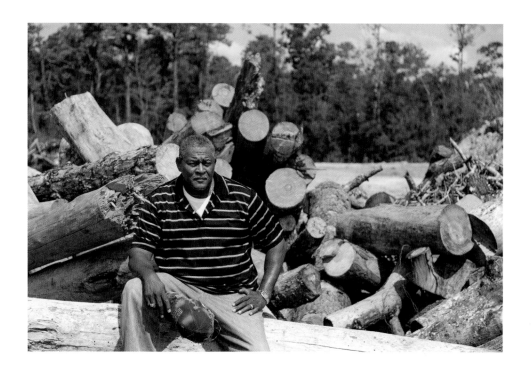

"The land, of course, will still be here in another twenty years, but I suspect it will look entirely different."

—Andrew Robinson

However, I also didn't want this experience to make me afraid to climb. I needed to get back in the saddle. Like I said, God's been with me.

There are four people working for me now. Two live in Tamina and two live in Conroe. I've worked a lot of guys from Tamina. They work for a while and then move on. In my business, there is always a high degree of turnover. It's hard work. I've bought a lot of equipment over the years to make the job as easy as possible, but when you're cutting down trees, there's no easy way to do it. The turnover comes with the territory.

I've bought a lot of special tools to help make the business easier. A log is difficult to pick up, so I bought a tractor. The brush is hard to get on the truck, so I bought a chipper. Then, I was introduced to a bobcat that will pick up the logs and put them on the truck, so I bought three. One day I saw Bill Beal and another climber send a crane to the top of a tree. A man put a sling around the top of the tree and put a hook in it that was connected to the crane and then slid half way down. He cut the tree at that point. The top half was taken down by the crane and placed beside the truck. I had to have a crane so bought one of those, too. It's made my business significantly more efficient.

My mother and grandmother were living here when I returned from Houston. My grandmother is now gone, but my mother still lives here, behind the tree shop. One brother lives in Montgomery, one sister in Port Arthur, and I have two sisters and a brother who live down the road.

Though I call Tamina home, my wife had a hard time living here. So, as soon as we had the down payment, we bought a home in Oak Ridge North, two or three blocks down the road from Tamina and across the tracks, and that's where we finished raising our kids. But I still think of Tamina as my home. It's where my business is, and I can't call any other place home. As a matter of fact, I've already made arrangements to be buried right across the street.

It's the people in this community that make Tamina so special and the love that they have for one another.

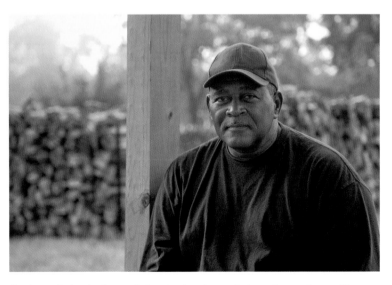

Andrew sitting in front of the stacks of wood along the main road in Tamina.

They've been here so long, helping each other, giving each other shelter, and sharing their food. It's family. Since it's such a small town, a lot of families, after breaking up, will marry another from the community. So, in many ways, we really are all family.

I would love to see Tamina grow. I'd love to see sidewalks, a courthouse, a fire department, and a police station. I'd love to see a sewerage system installed. I'm afraid it won't happen now with the cities growing so closely around us. I think they want to take Tamina.

I don't think we've got the right people in place, including myself, to lead Tamina. I remember something the late Rev. Jones's wife said when I was a teenager and she found out I was going to church in Houston. "That's what's wrong with Tamina. You kids get raised up and go somewhere else." From that I gather we should teach our children to have pride in their community, and let them lead the way. We have some good leaders in church, but as far as leading this community to make it economically viable, I don't think we have enough people to lead that particular effort. I blame myself too. I was one of the people who graduated from high school. I should have come back and helped more.

When I first moved here, Tamina went all they way up to the highway, but that land was taken for back taxes. Maybe, if I had more knowledge of the laws and had other people to help, we could have made more significant changes. If there had been twenty of us who shared a vision, I think that we could have made this a thriving town. With the financial pressures around us, I'm afraid that without a miracle, it might be too late to preserve Tamina as we know it. The land is being taken, and still there is no clear vision.

The land of course will still be here in another twenty years, but I suspect it will look entirely different and possibly have a new name.

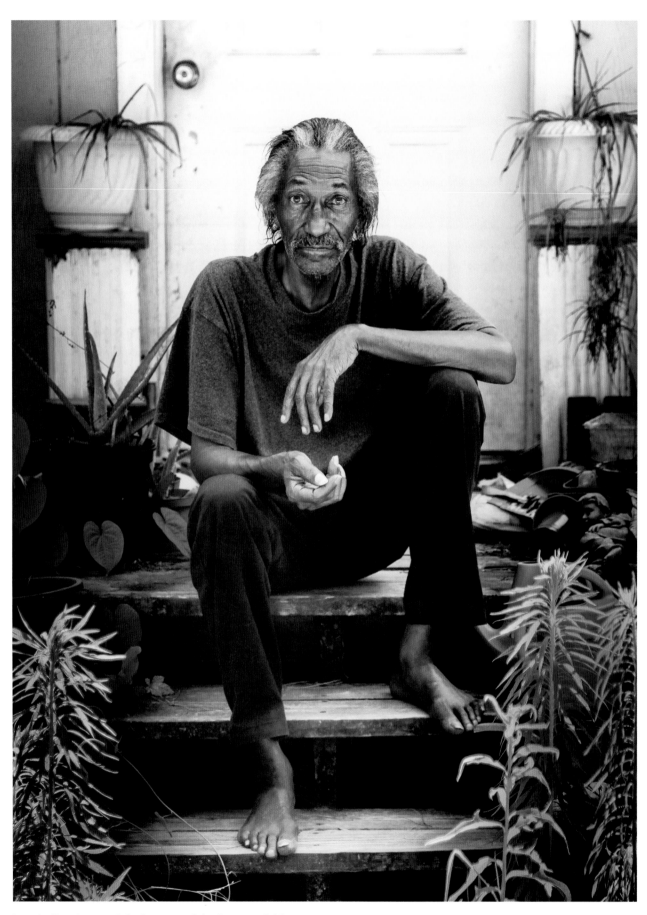

Lonnie Pitts is one of the keepers of the lineage of this town.

# The Pitts Family

Lonnie Pitts is a keeper of his people's stories. Though his people have a rich history, he worries Tamina's future is in jeopardy.

I was born in 1944—August 26. I was named Joseph Afron Pitts but everyone in town called me Junior. I didn't like that so much, so I just changed my name to Lonnie like my dad. I've spent most of my life in Tamina.

Don't know if you noticed, but a lot of us have blue eyes. I figure that's due to the white blood in our ancestry. We all have a mix of Indian, black, and white. My grandma was Indian—I was told she was Apache, but she was born in Navasota where the Badai Indians lived, so I'm not sure which tribe she was really from.

In the 1950s, Tamina was beautiful. There were no towns around us but Rayford and Conroe. It seemed like the land went on and on. In the summertime, I spent most of my time hunting and fishing—deer, 'coon, rabbit, squirrel. I learned to swim in one of the ponds around here. Years later, when the cities were being built around us, the builders would truck in all their trash from the work sites and dump them into our ponds, polluting them so bad all the fish died. We couldn't get anyone to stop them.

The Taylors and the Piersons were two of the first families to settle in Tamina back in 1871. That's when the Houston & Great Northern Railroad finished building the tracks from Houston through

Logs being loaded onto a tram loader for transport back to a mill. Notice in the lower section of photo that the tracks are portable.
*Photo courtesy of Heritage Museum of Montgomery County*

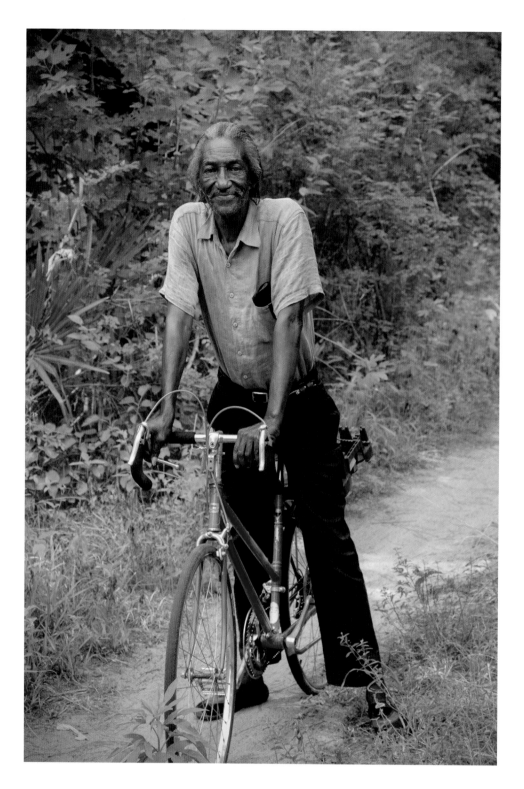

"We worry Tamina won't be here another ten years. . . . We are scared to make the agreement allowing neighboring towns to provide us with utilities, because it may give them a way to take our land."

—Lonnie Pitts

Montgomery County to Conroe. My dad told me freed slaves came here from all over—Georgia, Louisiana, Alabama, the Carolinas, and around Texas because of the lumber work they could find. Farming brought people here too. Land could be bought for fifty cents an acre back then.

When the Grogan Cochran Lumber Company came in and bought some 3,000 acres for their sawmill back in 1917, that's when Tamina began to shrink in size. Shenandoah then bought a bunch of my uncle's farmland. When he got old, I guess it was too hard to keep it up. I remember he plowed every bit of that land with one horse. And, Oak Ridge High School was built on Miss Evan's hog farm.

I remember the train would stop in the switch down by where the cement company is now, and the pulpwood would be loaded to take into Houston. The logs were four-and-a-half to five feet long. Huge pine trees. Those men would pick up those logs like they were twigs. I swear they were strong—they were all muscle. Watermelons could bounce off their biceps.

Tamina was also known as a whiskey town at one time. My big brother brewed it for a while, and he told me how to make it and took me to his distillery. I never did make any though. I would have been skinned if I made whiskey like him or Joe Rhodes.

After all these years, the people of this community have stayed close knit. I think it's because of the churches. They are different denominations, but they come together. The pastors decide what is best for their parishioners. They never step out on the sea, though. They're trying to improve in the ways that they know. Change is slow, because they can't seem to get together on one subject. If they could, then they'd be able to accomplish something. The main problem right now for us is the lack of a sewer system.

See, right now, a lot is burdening us down. We're worried Tamina won't be here another ten years. We worry that if Shenandoah or another town close by puts our utilities in, they'll have a reason to annex Tamina and can probably tax the residents out of Tamina. We're about to lose the property from Home Depot to the track. I hear Shenandoah has bought more land to put in a hotel. Tamina's looking to lose that whole parcel of land.

That's why we're scared. If they take this from us, where are we going to live?

Grogan Cochran Lumber Company placed the mill west of the railroad tracks on land where Lamar Elementary and Tamarac Park are today. *Photo courtesy of Heritage Museum of Montgomery County*

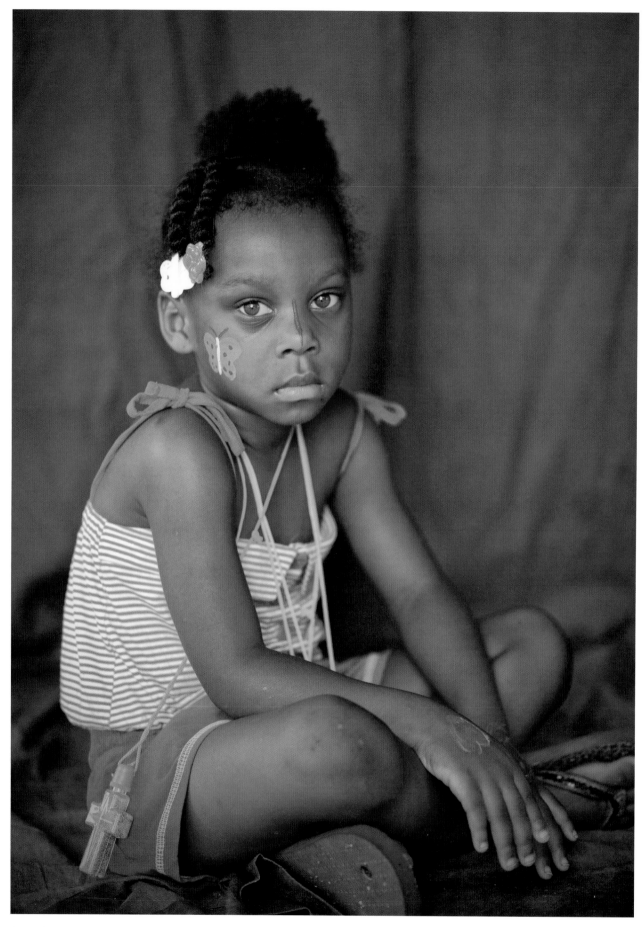

Mariah

# The Faces of Tamina

Jermany

Javarin

Eddie Pierson, Johnny Jones, and Annette Hardin

Cynthia McCullough

Robert Henry

Trenton

"Developers often approach us asking us to sell our land. The value they place on it is vastly different than ours. What they don't understand is that it's not just property—it's our legacy. The land represents the blood, heart, and soul of our African American heritage. I can't imagine ever being able to let this land go."

—Annette Hardin

Reverend Ginns's granddaughters Brianna, Cheyanne, and Jimaniece.

"'The Congo to Conroe' is the phrase used to describe Galveston Port. Galveston was the largest slave trade port in the U.S.—larger than Georgia. Once the slaves were freed, the port was used as an entrance into the new land of opportunity. Texas offered a promise of inexpensive fertile land and work as ranchers or in the logging industry. When the Depression hit, even more found their way to Montgomery County. Oil had been struck which created a sense of hope for a better life."

—Chuck Easley

William "Bubba" Webber

Markala

Diamond

"My mother was the first African American 4-H leader in Montgomery County. While we were told what we could not do in society, my mother taught us the opposite. Our home was a United Nations. She invited all the kids to our home, regardless of their color."

—Rita Wiltz

Gravestones found in the Wilburton Cemetery. Fussell's is one of the two oldest markers, dating back to 1899.

# Grave Stomping

"In order to document all the sites of a cemetery, you have to go grave stomping."

Two cemeteries flank Tamina.

On the south side of town, there are fewer than twenty grave markers in Tamina Cemetery, a.k.a. Wilburton Cemetery. Unfortunately, many of the markers have worn to the point of illegibility. The burial dates cover one hundred years. The two oldest graves belong to Calvin Fussell, born 1834 and died 1899, and Joel N. Herring, born 1859 and died 1899. Fussell was a private in Madison's Regiment of the Texas Cavalry Confederate States Army.

There is a second cemetery on the north side of Tamina called Sweet Rest Cemetery, where many generations of the Tamina families have been buried.

Sadly, this cemetery is in poor shape. Located in a low lying area, Sweet Rest floods each time it rains heavily. This became an issue several years ago. Some say beavers have built dams on a neighboring property keeping the water from flowing naturally through town. Some say the building of the nearby football stadium may have had an adverse effect on the water table. Others believe the building up of land around the artesian well has constricted the flow of heavy rains. Regardless, the flooding has caused markers of the graves to sink into the soft ground. While burials can still be held in Sweet Rest, most families now choose to bury their loved ones in Conroe.

Grasses grow high above the graves. Many of the markers are worn. Some grave sites are marked with a handmade wooden cross with the names and dates penned in or noted with sticky-backed letters. Some names are traditionally engraved into headstones and others were handwritten with a stick into then-wet blocks of cement.

It used to be tradition to spend a day cleaning up the cemetery during the Juneteenth celebration. Now, the churches get together and choose a day to go down to the cemetery. Usually it's the Saturday of the Memorial Day weekend.

Sweet Rest Cemetery floods
each time there is a heavy rain.

As is the tradition of the black culture to place a cemetery behind their church, land was chosen to be placed behind Lone Star Baptist Church. Brady Bashful, John Elmore, Will Pierson, and Tom Pierson were members of the committee given charge to establish this cemetery. When they debated on the name, Louise Williams, John Elmore's mother, talked about what a sweet resting place they had found. The name stuck, and with that, the cemetery became known as Sweet Rest Cemetery.

Two members of the Montgomery County Genealogical Society and Tamina resident Rita Wiltz went grave stomping and mapped the cemetery in 2005. They bought a GPS to register the exact location of each tombstone and broke down the information found on each headstone into different categories—family names, gender, age, if they were veterans, and endearments engraved on the headstones.

"Some headstones had pictures of those who were deceased. We learned babies had been buried, and their mothers were later buried on top of them.

Rita Wiltz worked with the Montgomery County Genealogical Society to map Sweet Rest Cemetery.

Some of the headstones were illegible. When we came across those, we made a rubbing of them to be able to read what they said. We documented the exact wording to each. It was challenging work. Many of the gravestones had sunk into the ground. We had to dig around and use a switch broom to get to the information on the stones. After we completed the documentation of the cemetery, we had an aerial photograph made to complete the documentation, and we invited the community to come help clean the grounds.

"There were a few strange discoveries as we worked our way through the cemetery. Miss Maggie's cross marker moved. No one is sure who moved it, but it was originally placed in the southwest corner with Lonnie Pitts' family graves. While we were documenting the whereabouts of each, we discovered her marker

had been moved to a place further northeast beside her step-brother's grave. Maybe one of the family members decided they needed to have 'her' placed amongst closer relatives.

Because of the continuous flooding, many of the tombstones have sunk into the ground.

"While we were working, the daughter of Eddy B. came to visit her father's grave. She was in a state when she read the tombstone and realized they had engraved the incorrect year of his death and was dumbfounded why nobody had noticed it all these years.

"When we were mapping my family's grave sites, I pointed to Aunt Marie's grave. I mentioned to Darlene and Jo Lynn how I wished Uncle John could see me doing this important work, and I wished he would show me a sign that he was proud I was doing this. At that moment, a huge rabbit jumped straight out of the place Uncle John was buried. We had just recently manicured this area, so we don't know how we didn't see the rabbit beforehand. But he jumped straight into the air and turned around and then disappeared into the woods. We screamed in surprise and then looked down, and Uncle John's headstone was gone! It was gone! It's not just odd. It's past odd. We looked at each other and Darlene said, 'Well, don't be asking for any more signs. We need to get this project done.' We laughed so hard, but I swear I didn't sleep for weeks afterwards trying to sort out that mystery.

"My daddy is filled with wisdom, so I asked him what he thought might have happened. 'The only thing I can think of is that the stone has sunk into the ground. Who knows? When it rains, it becomes a swamp.' Of course this makes sense, but it doesn't explain how it disappeared before our eyes.

"There are many veterans out there. The first African American woman veteran in the Conroe area was one of Odessa Amerson's daughters. We counted seven or eight veterans. The oldest person to be buried was my grandmother, Aunt Marie. She was 103 when she passed away."

In all, there are sixty-one gravestones recorded, one additional one for John Elmore could not be recorded since the headstone was never found.

Many of the
headstones are
hand-made with
names either painted
onto crosses or
etched into concrete
markers.

# Poverty: Caught in a Trap

*Wanda Horton-Woodworth*

"When my sisters and I were young, our parents pushed us to better ourselves. We wanted to go to college. We wanted a good job. We wanted to get out of Tamina. With a lot of hard work and determination, I did get that education and job."

When I first rode into town in my big Cadillac, people said I was rich. I corrected them and said I had a job and learned how to budget my money. People also said I was stuck on myself—seems like they think anyone who rises above the poverty level must think they're somebody. But you know what? I do think I'm somebody. I went to college. I went to work. I wanted to better myself. My family believes each generation should do better than the last.

That's not the thinking for many in Tamina. They have the mind-set that life is pretty good, so why should their children's be any different. They don't push

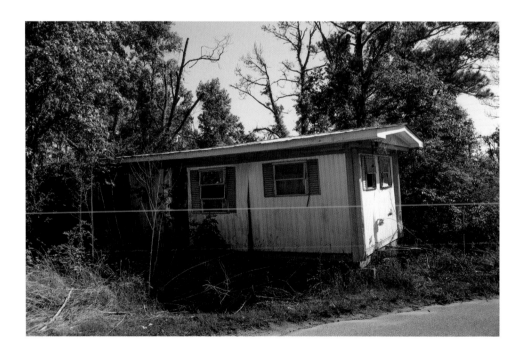

their children to excel. Maybe they don't want to do more, because they know if they do, then society will expect more of them. It makes me sad that so many choose to stay in this position. We all are given the opportunity to make choices.

I look around and see so much junk in people's yards. When they look around though, they see dollar signs. It's a whole different way of thinking. Where I see a junk car, they see that somebody might one day need a muffler or starter from that car. They hold on to these things like memories, like ornaments to happy times in their lives. It's not just the old folks here. Young people think this way, too.

There is little incentive for adults living in poverty to change their economic status. They are caught in a trap. Remaining poor, they are provided support— they know they will have food on the table, their children are guaranteed a hot lunch each day at school and receive school supplies, and they qualify for free health services.

Without a skill or higher education, they most likely will only find work with schedules at odd hours making minimum wage. Unless there are other adults at home, their children will have to be left alone, they will not make enough money to keep food on the table, their children may have to manage their days at school hungry, and they will lose their health services.

I believe they all want a good job, but there is the overriding fear of the unknown. I grew up with many who would walk up to the highway and look north and then south and say, "No, I'm staying here."

# Entrusting Voices to History

*Tacey A. Rosolowski*

"Creative people know that stepping outside of a comfort zone can make great things happen."

Marti Corn took this path when she picked up an audio recorder as well as her camera, so she could interview the residents of the Tamina community. Her journey continued when she decided that, rather than summarizing the interviews in her words, she would erase her own presence and let the subjects' voices shine out in first-person narratives to accompany the photographs. I was delighted when Marti asked me to turn the transcripts of her first interviews into essays, providing insight from my own work as an oral historian and essayist.

For the oral historian, Marti's choices address basic questions about power. Who decides whose words will be heard? Who determines how a person's story—or the story of a whole group—is told? Any artist has enormous control over her material and content. Yet Marti relinquished some of that power by allowing the residents' words to drive the Tamina story. I told Marti that she intuitively followed oral history practice by inviting speakers to tell their stories in their terms, complete with digressions, confessions, and interpretations. (Coincidentally, freed slaves were some of the first subjects interviewed when the field of oral history evolved in the early twentieth century. Marti's work in a freedman's town touches the roots of the field.) These conversations can be very interactive and intimate. In her Afterword, Marti confirms that this type of bond evolves only with time and the interviewer's demonstrated will to listen carefully. Only in a trusting relationship will an interview subject venture beyond the sunny spots of a personal story and journey into complexities and the dark underbelly of human experience.

My essayistic work began at this point. The first-person essay is a perfect form for *The Ground on Which I Stand* because it allows each Tamina resident to speak as an "I" and confide in the reader directly, suggesting the trust that enabled the speaker to bring his or her experiences to light. The quality of the voice in each essay also gives the reader a strong impression of a living individual

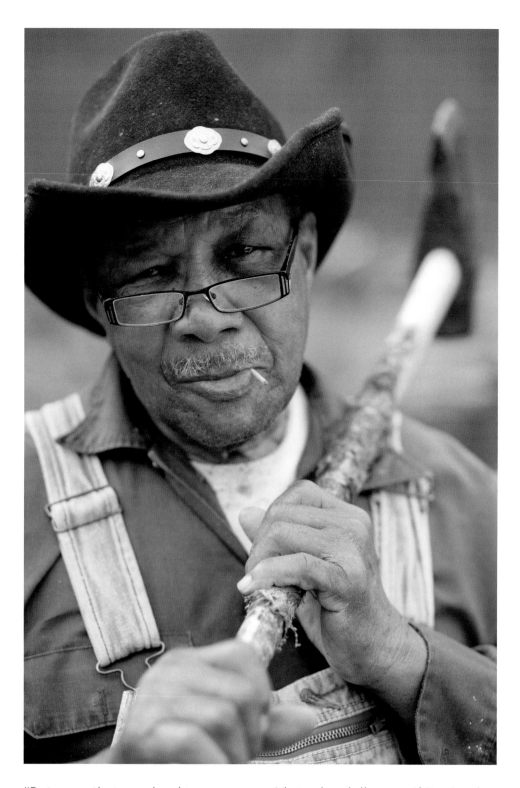

"But man, that was hard to come up with twelve dollars . . . if it rained, we couldn't make nothing."
—Joe Rhodes

whose personal qualities come through witty turns of phrase, sentence rhythms, personal quirks, and habits that indicate background and community affiliation. As I read through Marti's transcripts, I could hear the range of styles. Joe Rhodes reminisced: "But man, that was hard to come up with twelve dollars. . . . If it rained, we couldn't make nothing." I smiled at Reginald Chevalier's playful "whys and why nots" and nodded at Shirley Grimes' passionate, "I don't ever want kids to go through fear. Fear is hard." Such expressive lines are gold for an essayist, so I carefully preserved them and wove them in among passages that developed each essay's central theme.

It took a lot to coax the voices of Tamina to speak. The essays allow the reader to share a bit of that process. The reader can receive their words as confidences offered, just as they were trustingly shared with Marti. Is there more to tell about Tamina? Of course. Undoubtedly, community members excluded some stories and told others off the record. Oral histories inevitably present a faceted, subjective, and partial truth about collective experience. But through a carefully-built trust, once-private tales have new life as a public history, and so the voices of Tamina are poised for a new phase of evolution.

# AFTERWORD

Honestly, I was terrified to knock on the doors in Tamina. After all, I was an
outsider. I knew only one person in this town, and except for the few paragraphs
I found in my initial research, I understood very little about their community.
How would they receive me? Would they be offended? Would they slam their
doors in my face? So, how did I end up arriving in Tamina with my camera and
recorder in hand?

Since moving to Montgomery County in 1998, I witnessed church groups,
concerned citizens in The Woodlands, and non-profit organizations working
tirelessly, taking great effort in assisting these people. I also read about attempts
to force residents out of Tamina by questionable means or through increased
taxes by surrounding communities. I listened to people speak of Tamina with
disrespect, seeing it only as an eyesore and suggesting the people abused public
services.

In 2008, when my youngest son began playing basketball with Jaren, a boy
who lived in Tamina, they became fast friends, and my curiosity deepened. I found
myself roaming her streets. The more I saw, the more convinced I became that
this was a historically significant town with important stories to be told.

I began to think that if only there were more documentation on this town,
explaining its historical relevance, then perhaps those who share cynical views of
this town might see Tamina in a new light. Maybe they would recognize Tamina
is more than just valuable property to be made into warehouses or another
subdivision.

It was then I decided to find a way to produce a book filled with portraits and
historical information gathered from Tamina's residents. I would distribute copies
to The Heritage Museum of Montgomery County, The Library of Congress, local
libraries and schools, and offer it as a gift to Tamina's residents.

With this intention, the project began. It evolved organically. I first introduced
myself to Shirley Grimes, the director of the Tamina Community Center.
Without hesitation, she invited me to come with Ben DeSoto, a Houston-based
photojournalist, and teach the children at the center how to see their world

through the lens of a camera. They wrote in journals each week, describing their family and home, and they were encouraged to talk about their history at the dinner table. The transformation we observed in each of the thirty-two kids, ages three to fourteen, was remarkable. Their self-esteem and self-awareness rose as their pride in their families' history became known.

As I worked with these children and immersed myself in this community, I was anxious to make portraits of the residents. When I met with them, they shared their stories—childhood memories, narratives passed down from one generation to the next, challenges faced, their strong bond with one another, and their fear of an uncertain future. They made it clear this project had to expand to incorporate both the images and their stories. Portraiture alone would do them a disservice.

I drove through Tamina daily, visited churches, participated in their trail rides, and volunteered at their fundraisers. People stopped me in the street wanting to know why I was there. Some immediately welcomed me into their homes while others were cautious and distrustful.

It took a year to gain Rita Wiltz's trust. At last, on a Sunday morning, when I was attending the Falvey Memorial Baptist Church, she took my hand and led me to the pulpit saying, "If anyone needs to be prayed for, it's you and your project." After the service, she pointedly asked me why I was really there. When I said I wanted others to see that Tamina was worthy of celebration, she told me to wait. Twenty minutes later, she arrived with family members representing four generations and sat everyone down in front of me. Each began telling stories of their descendants and memories of growing up.

From that point forward, I was accepted as an honorary resident of Tamina. I have celebrated with them during reunions and birthdays, shared meals around their kitchen tables, and have wept with them when a loved one has passed away. I've fallen in love with these people and am greatly enriched by their friendship.

I anticipated spending a year on this project and then easing my way into another story elsewhere. Instead, I have spent more than four years documenting their lives and sharing their stories with others. And I cannot see an end to this journey. Interest in this project has stretched far beyond my imagination, solidifying my belief that Tamina has a rich living history that others want to celebrate and confirming the power of combining the portrait and the story.

Rice University hosted a solo exhibit of Tamina's photographs and oral histories during Houston's 2014 International FotoFest. I have given lectures at local charitable groups, Lone Star College, Rice University, and Texas Southern University. Conroe Independent School District and Harris County schools have recognized the importance of Tamina's history and are now offering the story

of Tamina as part of their social studies program, for all grades, kindergarten through twelfth. Several residents of Tamina have agreed to write the curriculum. Three young filmmakers from Colorado—Sam Carrothers, Robert Ortega, and Lotem Sella—are producing a documentary film about Tamina. Surrounding community leaders, including The Woodlands Rotary Club and Lone Star College, are taking a renewed interest in Tamina and her residents. Their story is gaining national attention, with exhibits being scheduled in museums and universities around the country. And instead of me self-publishing this book, Texas A&M University Press has published it.

I consider myself a documentary portrait photographer. As such, I use my images to remind us there is a common thread that binds humanity. When I work with those who live in ever-present poverty, are trapped in war-torn regions, or are stripped of their human dignity, I am always in awe of their ability to remain hopeful—their faces projecting strength, courage, and tenacity, their words strengthening these impressions.

My hope is that everyone who sees these images and reads the stories in this book will connect, empathize, and celebrate the challenges these people have overcome. I hope we will all share in their dream for a future on this land.

Robert Henry celebrating his ninety-seventh birthday with Marti. He passed away June 24, 2014, at ninety-eight. *Photo courtesy of Rita Wiltz*

# APPENDIX: TAMINA TIMELINE

**1863**
Emancipation Proclamation is signed.

**1865–June 19**
Slaves represent 30 percent of the population in Texas. Union Soldiers land in Galveston with news the Civil War has ended and those enslaved are now free.

**1871**
Houston & Great Northern Railroad completes expansion of tracks from Houston through Montgomery County.

**1871**
Families migrate from surrounding counties, as well as southern and eastern seaboard states, to establish Tammany (eventually known as Tamina), a freedmen's town. They represent some of the 1.8 percent of freed slaves who have the funds to purchase land.

**1882–1968**
A recorded 3,446 blacks and 1,297 whites are lynched throughout the southern states.

**1944**
Even though Congress passes the Fifteenth Amendment in 1870, giving African American men the right to vote, it is not until 1944 that the first African American votes in Montgomery County.

**1949**
Phyllis Wheatley school, a one-room schoolhouse in Tamina, closes. Students are then bused to Conroe to attend Booker T. Washington.

**1960s**
Lake Chateau Woods Subdivision is developed. It incorporates in 1975 and becomes The City of Chateau Woods.

**1962**
Tamina gets electricity.

**1964**
Oak Ridge North is established when Arkansas-based Spring Pines Corporation purchases a large tract of land two miles north of Spring Creek to build a subdivision. More land is purchased in 1969 and the subdivision expands.

**1979**
Oak Ridge North incorporates.

**1981**
Oak Ridge High School opens on land that was once one of Tamina's hog farms. Tamina students attend Oak Ridge.

**2014**
Tamina is home to more than five hundred people. It still has no sewage system, few roads are paved, ponds are polluted with garbage dumped by builders when the surrounding cities and towns were developed, and children continue to walk to school in the streets, because they have no sidewalks. Despite these challenges, Tamina's residents are determined to stay.

**1876–1965**
The Jim Crow laws are enacted to enforce racial segregation.

**1917**
Grogan Cochran Lumber Company is formed on three thousand purchased acres, and a mill is built in Tamina, located where Lamar Elementary and Tamarac Park stand today.

**1927**
Grogan Cochran Lumber Company cuts its last timber and shuts down its Tamina operation.

**1929–early 1940s**
The Great Depression causes a rise in unemployment and a crash in the farming industry, forcing tenant farmers and sharecroppers off the land throughout Montgomery County.

**1931**
George W. Strake strikes oil six miles southeast of Conroe, creating an oil boom that attracts fortune-seekers, financiers, and roughnecks to the area.

**1964**
George Mitchell, oil tycoon, purchases fifty thousand acres from the Grogan-Cochran heirs. The Woodlands is developed on 2,800 acres that previously were used for the Tamina Mill.

**1967**
Schools are integrated. African American students in Montgomery County begin attending Conroe High School.

**1970s**
Tamina's cafés close.

**1973**
A water system is implemented in Tamina.

**1974**
The Woodlands starts selling homes. Shenandoah, which began as a housing development for Houston commuters, incorporates. Tamina students begin attending local schools.

# ACKNOWLEDGMENTS

My deepest gratitude goes to those who call Tamina home. I am humbled by their willingness to share their stories, their generosity of time, and their openness to invite me into their homes and lives.

Ben DeSoto patiently guided me as I began this project. Together, we visited Tamina's churches and cemeteries, joined a trail ride, and broke bread with those at Falvey Memorial Baptist Church. We worked with thirty-two children to help them realize the rich history of their town and people. His encouragement gave me the confidence to knock on so many doors.

Doug Beasley is both my friend and mentor. He taught me to be still, to allow the imagery to make itself known, and he helped me find quiet so I may hear where my heart is leading me.

Gus Kopriva encouraged my creative discovery and curious spirit, welcomed me into his artists' circle, and gifted me a month of solitude to work on this book.

Thank you to Geoff Winningham, who recognized the importance of this story and provided me with the first venue to share Tamina's story at Rice University.

Meeting George Lindahl was a wonderful surprise. He is a generous soul who helps make this world a better place.

I'm grateful to Thad Sitton, who believed in this project and wanted to share his revealing knowledge of freedmen settlements in this book.

Opening night of the photo exhibit at Rice University during Houston's 2014 International FotoFest. *Photo courtesy of Ben Tecumseh DeSoto*

Tracy Xavia Karner supported this project on so many levels. I'm grateful for her guidance, her poignant essay, and her recommendation that led to Johnny Jones's image entering the permanent collection at the Museum of Fine Arts, Houston.

Tacey A. Rosolowski not only transformed many of the transcripts into first-person narratives and shared her wisdom in retaining the language and integrity of each, but she wrote an equally eloquent and humbling essay to be included in this work.

Donna Mosher and Mark Cooper poured over the manuscript proofs with their skilled editors' eyes, generously offering their guidance.

Thank you, Cherry Weiner, my agent, who guided me so thoughtfully through the business side of this publication.

Shannon Davies provided the needed encouragement and enthusiasm to continue my search for stories and images in order to make this book worthy of publication by Texas A&M University Press. And my editors, Thom Lemmons and Patricia Clabaugh, were ever-present with their wisdom and patience.

Thanks to my amazing friends and guides who offer ever-present support: Matt Adams, Dominick D'Aunno, Ed Jones, Kathleen Adey, Ann Wolford, Mary Jo O'Neal, Cressandra Thibodeaux, Kata Fountain, Ana Rodriguez, and my tribe at Northwoods Unitarian Universalist Church.

My dear heart, Hallie Moore, lifted my spirits each time I hit an obstacle and had champagne and praises pouring with every milestone met.

I send my heartfelt gratitude to my siblings Bobbi and Bill, and sister-in-law Katie, for the countless phone conversations over the years as I struggled through and celebrated the many facets of this project.

And to my children, Brae and his partner Megan, Jamie, and Jesse, who love me despite my wanderlust and are always my greatest source of encouragement in following my heart.

After so many years, there are so many who helped make this project a reality. You know who you are, and you know how grateful I am for your support.

Thank you, all!

# CONTRIBUTORS

## Wanda Horton-Woodworth

Wanda Horton-Woodworth was raised in the historic community of Tamina. After being awarded a four-year scholarship to Sam Houston State University by Ms. Bess Fish through the 4-H club of Montgomery County, Horton-Woodworth received her bachelor of arts and master of education. She also studied mid-management at Prairie View A&M University.

A lifelong educator, Horton-Woodworth taught for thirty-six years in the Windham School System (TDCJ-ID) in Huntsville, Texas, and then returned home to give back to her community.

Since retiring, Horton-Woodworth has continued to promote higher education to others by volunteering for organizations such as Special Angels of The Woodlands, Children's Books on Wheels, Conroe Independent School District, and Alpha Kappa Alpha Sorority, Inc., where she is a charter member. She also works with at-risk youth, special education students, HIV/AIDS organizations, and CASA. She's a certified Alzheimer disease caregiver and is the founder of Inner City Entervention, a 501(c)(3) organization that provides transitional services for the families of ex-offenders and works to reduce the number of at-risk youth entering the criminal justice system.

## Tracy Xavia Karner

Tracy Xavia Karner is an author, curator, photography enthusiast, and visual sociologist. She has a background in painting, textile arts, and photography, as well as graduate degrees in sociology. Using visual technologies and resources to study the social construction and transformation of self and identity, Karner has explored these processes on the individual, social-cultural, organizational, and community levels in a variety of contexts. Additionally, she has authored numerous articles and essays exploring visual and cultural perspectives with regard to photography, art aesthetics, gender, mental health, and social policy in both popular and academic venues.

An award-winning teacher and a nationally-known expert in the field of qualitative sociology, Karner is the coauthor with Carol Warren of *Discovering Qualitative Research: Ethnography, Interviews, Documents, and Images*, 3rd Edition, (Oxford University Press, 2014).

Karner is on the faculty of the Sociology Department at University of Houston and teaches courses in Visual Sociology, Sociology of Art, and Sociology of Culture. She is currently working on a monograph about the social history of the Houston photography community.

## Tacey A. Rosolowski

Tacey A. Rosolowski is an independent oral historian and owner of History-Capture, providing interviewing and project-development services to organizations including MD Anderson Cancer Center, the University at Buffalo Galleries, The Foundation for the History of Women in Medicine, and the Smithsonian Institution.

Pursuing her interest in art, Rosolowski has interviewed numerous artists for her lectures and critical articles.

She also writes creative nonfiction, and her essays have appeared in such literary journals as *Salmagundi*, *Boulevard*, and *The Antioch Review*.

## Thad Sitton

Thad Sitton, a native of East Texas and doctor of philosophy graduate of the University of Texas at Austin, wrote his dissertation in the 1970s on using oral history in the classroom, using the Foxfire approach, and has been collecting oral histories of Texans ever since. Joining forces with Baylor University, Sitton participated in 1983 in the establishment of the Texas Oral History Association. Then, as information director of the Texas 1986 Sesquicentennial Commission, Sitton, in cooperation with TOHA and Baylor University, coordinated a statewide series of oral history workshops to introduce preservation groups and local historians to the techniques, art, and value of taping memoirists.

His literary achievement and scholarship utilizing oral histories for grist for his numerous historical monographs demonstrate in the best possible way the validity of oral narratives as historical evidence in modern social history.

According to Baylor University, Thad Sitton ranks among the nation's most respected oral historians.

# RESOURCES

58 Engineers and Exit Bands
www.magneticrecordings.com/exit

Children's Books on Wheels
www.childrensbooksonwheels.org

Heritage Museum of Montgomery County, Texas
www.heritagemuseum.us

Interfaith of The Woodlands
www.woodlandsinterfaith.org

Montgomery County Genealogical and Historical Society, Inc.
www.mcgandhs.com

Montgomery County United Way
www.mcuw.org

Shenandoah Visitors Center
www.shenandoahtx.us/CVBhom.cfm

Tamina Community Center
www.Taminacenter.org

BillionGraves
www.billiongraves.com

# INDEX

whiskey, making and selling, 52
wood, chopping and selling, 47, 51
"Entrusting Voices to History"
    (Rosolowski), 119, 121
Exit (band), 74, 77

faith, 29, 60–66, 90, 92. *See also* religion
Falvey, James C., 55
Falvey, Matilda A. B. (earlier White), 55
Falvey, Seymour, 38, 51, 54–59, 79, 80
Falvey family, 54–59
Falvey Holland Clinic, 55
Falvey Memorial Baptist Church, 38, 58, 61,
    62–63, 66, 80
family
    as community, xiii
    defined, 17
    feeding the, 26
family reunions, 42
fathers, 17, 21
58 Engineers (band), 77
Fish, Bess, 42
Flaherty, Robert, xi
Fodice, xx
Foland, Burl, 90
food
    early residents, 34
    feeding children, 51, 61
    hunting for, 52
    lack of, 51–52
    sharing, 80
4-H Club, 41–42, 107
freedmen
    employment, xv, xvii, xix, 38
    land ownership, xv, xix
freedmen's settlements, xix–xx
friendships, 17
funerals, 61
"Funky Fly" (Exit), 77
Fussell, Calvin, 108, 109

Galveston Port, xv, 106
Ginns, Elvin, 61, 62–63
Ginns, Jimaniece, 61, 65, 105
Grant's Colony, xx
Gravis, Jane, 54–55

Great Depression, 30, 127
Grimes, Ranson, xiii, 23, 68–69
Grimes, Shirley, xiii, 68–71, 121
Grimes family, 68–72
Grogan Cochran Lumber Company, 97,
    127
Grogan family, 38, 40, 79

Halls Bluff, xx
Hardin, Annette, 99, 103
Harper, Douglas, xii
Hayes, Herbert T., 73
Hayes, Patrick, 73
Haywood, Clara (earlier Williams), 38
Haywood, Willy, 38
Haywood-Coleman, Clara, 41
Haywood-Henry, Della Mae, 28, 41, 43
healthcare, 80
Henry, Robert, 101, 125
Herring, Joel N., 108, 109
High, Clennis, 77
home building, 19
homes
    on church land, 69, 71
    described, 1
    early residents, 29, 33, 79
    number of, 19
    photos of, 2–4, 6–11, 14–15
    Randle family, xviii
horses
    Chevalier family, 20
    in the community, 1
    photos of, xxii, 15, 20, 22–25
    prevalence of, xiii
    Schuster family, 22–26
    Thanksgiving trail ride, 22–26
Horton-Woodworth, Wanda, 31, 41–45,
    117–118, 131
Houston & Great Northern Railroad, 95,
    126
Hughes Tool Company, 89
hunger, 51–52
hunting for food, 52

ice, cost of, 51
infrastructure, 1, 80, 81

## Other books in the
## Sam Rayburn Series on Rural Life